A–Z
OF
WARWICK
PLACES - PEOPLE - HISTORY

S. C. Skillman

AMBERLEY

First published 2023

Amberley Publishing
The Hill, Stroud, Gloucestershire, GL5 4EP
www.amberley-books.com

Copyright © S. C. Skillman, 2023

The right of S. C. Skillman to be identified as the Author of this work has been asserted in accordance with the Copyrights, Designs and Patents Act 1988.

ISBN 978 1 3981 1576 7 (print)
ISBN 978 1 3981 1577 4 (ebook)

All rights reserved. No part of this book may be reprinted or reproduced or utilised in any form or by any electronic, mechanical or other means, now known or hereafter invented, including photocopying and recording, or in any information storage or retrieval system, without the permission in writing from the Publishers.

British Library Cataloguing in Publication Data.
A catalogue record for this book is available from the British Library.

Origination by Amberley Publishing.
Printed in Great Britain.

Contents

Introduction	4
Actors at Playbox Theatre	5
Bridges Across the River Avon	7
Conservatory and Parterre or Knot Garden	9
County Mental Hospital	12
Court House	14
Dungeon at the County Gaol	17
Earls of Warwick	19
East Gate	22
Eagles at Warwick Castle	23
Folk Festival	26
Great Fire of Warwick	28
Globe Hotel	30
Guildhall	31
Greatheed Family	33
Hatton Locks	36
Hill Close Gardens	38
Inheritance	40
Ichthyosaur	42
Incarcerations	43
Judges' House	45
Kingfisher Pool	47
Leper Hospital	48
Master's Garden	50
Mill Garden, Mill Street	51
Nelson Family	53
Oisin the Irish Giant Deer	55
Peacocks	56
Park Cottage	57
Priory Park	58
Quaker Meeting House	60
Racecourse	62
Randolph Turpin	64
Rous, John	66
Saltisford Canal Trust	68
Smith Street	69
Tudor House Inn	72
Trebuchet	73
Unitarians	75
Vehicles: the Austin Healey Motor Company	77
Warwick Arms Hotel	79
Warwick a Singing Town	81
West Gate and the Chapel of St James	83
X-rays at Warwick University	87
Yeomanry	89
Zenith	93
Bibliography	95
Acknowledgements	96

Introduction

> The armies of the queen hath got the field.
> Richard Plantagenet in *Henry VI Part III* (Act I Scene 4)

So says William Shakespeare, through the lips of the Duke of Gloucester speaking of one of England's warrior queens, Margaret of Anjou. Margaret (1430–32) was much stronger than her husband, Henry VI, and she was a worthy descendent of the woman who had founded the fortified town of Warwick over 500 years earlier, Aethelflaed, Lady of the Mercians.

Aethelflaed, daughter of Alfred the Great, built her fortress Waeringwicum on the River Avon in the year 914, which grew into the town of Warwick. Her conquest of the Viking Danelaw secured the creation of the Kingdom of England.

Ever since then, Warwick has been at the centre of England's history. After William the Conqueror ordered that a castle be built on Aethelflaed's chosen site, that castle and the Earldom of Warwick became one of the highest prizes in the dangerous and treacherous power game played around the English throne for centuries.

Today, Warwick retains many of its beautiful historical buildings, and is packed with the richness of the human story besides being a lively modern town. Here you will find not only several of its most treasured ancient buildings and glorious gardens but also some outstanding examples of its people, commerce, creativity, science and endeavour, community events, birds, and animals. My hope is that I have, through this book, given you a flavour of the life of Warwick and its people – past, present and future.

A

Actors at Playbox Theatre

> The actors are at hand; and, by their show,
> You shall know all, that you are like to know.
> Quince in *A Midsummer Night's Dream* (Act V, Scene 1)

As you drive from Longbridge along the Stratford Road into Warwick, heading in the direction of the West Gate, you will pass on your left a large box-shaped building, which belies the life-transforming work that goes on within. Inside, its versatile theatre studio space can be transformed in a multitude of ways to meet any creative requirement, which includes a 200-seat main house auditorium.

This is the Dream Factory, owned and managed by Playbox Theatre, a project created in Warwick in 1986 by Founder and Executive Director Mary King to establish an artistic environment in which all children and young people could flourish. Just a year later, Playbox received the funds to build the UK's first purpose-built and designed theatre for young people. The Dream Factory opened in May 1999.

Dream Factory, home of Playbox Theatre in Warwick, exterior. (Author)

A–Z of Warwick

I first discovered this theatre, and attended a production, just a few months after coming to live in Warwick: *Scheherazade: A Thousand and One Nights*. Its nine-year-old star gave a polished performance. The latest performance I attended, as at the time of writing, was *The Secret Garden*, a glorious production with an enchanted setting and inspiring young actors in every role.

How do Playbox achieve this magic? I believe the key is their outstanding team of highly creative theatre professionals, full of energy and enthusiasm, which translates itself to the children very quickly. Alongside that, for those who get deeply involved, it is a consuming passion, often taking up 100 per cent of the children's free time outside school, throughout the week and the weekends. Parents may register their children in the Theatre Training Programme at Playbox each season.

Several of the theatre's past members have, since their time at Playbox, claimed their places in the spotlight, and taken up careers in the acting profession including, most notably, Sophie Turner and Josh McGuire.

Playbox runs a Musical Theatre Programme, and the Theatre Training Workshops are open to all young people regardless of any previous experience. New workshop members rapidly gain confidence through their training; a workshop leader confirmed that 'the effect is usually visible after the first week'.

> Our directors ... aim to increase your courage as each moment with Playbox passes and you will soon find yourself leaping headfirst into every challenge...the more abstract and complicated, the better!

With performances to suit all audience types, Playbox have won acclaim all over the world for creating productions to the highest professional standards, performed by exceptionally talented young artists. The professional acting industry is a dream held by many but achieved by few: nevertheless, I believe every Playbox member may see their future life enhanced by the opportunity they had as children and teenagers to express themselves and gain emotional intelligence and self-confidence here in the Dream Factory.

Dream Factory, interior of the lobby. (Author)

Bridges Across the River Avon

> To ride on a bay trotting-horse over four-inched bridges.
> Lear in *King Lear* (Act III, Scene 4)

Before early medieval times, the inhabitants of Warwick crossed the River Avon near the castle via a ford. In the fourteenth century, a bridge was constructed there bringing travellers over the river, past a tollbooth at Mill Street, and then on into the town via a road close beside the castle. This served Warwick well for about 250 years. Many of the key figures in England's history passed over it.

By 1788, George Greville, Earl of Warwick, saw that the medieval bridge needed major repair. However, he was fed up with the public thoroughfare passing so close to his castle walls. He came up with a plan to take that traffic away from the castle, extend his private land and benefit the town of Warwick thereby. Accordingly, he recommended a diversion on the Banbury Road into town, leading past Bridge End, taking traffic several hundred yards upstream from the east side of the castle across a new bridge, creating much more space and privacy for the castle. He agreed to pay most of the cost of this project, obtained an Act of Parliament to carry it out, and appointed William Eborall to design it. The new bridge was opened in 1793, after William's death.

Close-up of Guy's Tower from the path which in medieval times would have been the public road by which all travellers from the south came into Warwick via the medieval bridge. (Author)

The old castle bridge was damaged by a great flood not long afterwards. Subsequently, the bridge became a picturesque ruin with the addition of planting. It can best be viewed through the windows of the top floor rooms of the castle, and of course from the battlements. Three complete arches of the medieval bridge remain. To this day the 1793 bridge carries traffic into Warwick from Banbury Road, affording all who cross an iconic view of the castle.

Above: Castle Bridge from St Nicholas Park. (Author)

Below: View of both bridges from the top floor of the castle staterooms. (Author)

C

Conservatory and Parterre or Knot Garden

> It standeth north-north-east and by east from the west corner of
> thy curious-knotted garden.
>
> Ferdinand in *Love's Labour's Lost* (Act I, Scene 1)

In 1749, Francis Greville, 8th Lord Brooke, called in the now legendary landscape designer Lancelot 'Capability' Brown to redesign, extend, and upgrade the landscape surrounding the castle. This was Brown's first major project, which inspired many other English landowners to employ him for their own projects. He removed all the traditional parterre gardens around the castle and replaced them with a sweeping landscape down to the river. Francis acquired the Nonconformist chapel, which stood on the site of the present Conservatory and absorbed the land into the castle grounds. In exchange the church received its present site in the High Street around the year 1758.

Nearly forty years later, Francis's successor George ordered a conservatory to be constructed to a design previously drawn up by local mason William Eborall in the 'playful gothic of the eighteenth-century'. Known as the Greenhouse, it was built specially to house the Warwick Vase, a monumental fourth-century Greek marble urn

A view of the Conservatory. (Author)

from Hadrian's Villa, Tivoli, which George had acquired from Sir William Hamilton in 1774. The Vase had first been placed at the centre of the castle courtyard. In the late twentieth century, a copy was made of this Vase, the original having been sold by the 7th Earl to the Burrell Collection, Glasgow, in 1978. Visitors to the Conservatory today see the replica of that original vase.

The Conservatory overlooks the parterre garden – a take on the traditional knot garden but simpler to maintain – created in 1870 by Robert Marnock under the instruction of George Guy Greville, 4th Earl. All who stand on the steps of the Conservatory gaze across the parterre garden and the Pageant Field to the River Avon.

The Conservatory (now listed Grade II) was restored in 1989 and, at the time of writing, contains ornamental planting and the replica of the Warwick Vase, alongside its use as an elegant tearoom.

Conservatory interior, showing the vase. (Author)

View of the Peacock Garden. (Author)

C

View of the Conservatory at the end of the long vista from the river. (Author)

Conservatory interior, showing the palms. (Author)

County Mental Hospital

> The country gives me proof and precedent
> of Bedlam beggars...
>
> Edgar in *King Lear* (Act II, Scene 3)

Anyone who visits Tredington Park at Hatton today will see a period property converted into luxury apartments. However, in its early years, those who approached this edifice may well have viewed it with a sense of dread and despair. For this building housed the local 'Lunatic Asylum' from the time when the government first ordered such asylums to be built. Warwick County Lunatic Asylum opened in 1852.

In the early days of the asylum, the professional approach to those with mental health disorders was severe, partly because these patients were regarded as 'bad' (and possibly possessed by the devil) rather than 'mad'. They could be locked up to prevent them from harming themselves or others, and visitors mocked and gawped at them (for example at Bedlam in London). Treatment was gradually introduced, but much of it was unlikely to be helpful (for instance cold baths and electric shocks). Small private 'lunatic asylums' were set up for patients who could pay, and for paupers supported by local authorities.

In 1930, following a shift in society's attitudes, the hospital underwent a change of name to 'Warwick County Mental Hospital'. Eighteen years after that, it became 'Central Hospital'. The wards there were named after famous Warwickshire people including George Eliot, Ann Hathaway, William Parsey (the first medical superintendent at the hospital) and John Conolly (a pioneer of humane treatment for mental illness).

Tredington Park. (Author)

It finally closed in 1995 to make way for a new provision providing age-independent mental health care at St Michael's Hospital, further towards the town centre.

The history of the asylum spans 140 years. Several of those who spent time there as patients during the later decades of the hospital have positive memories, for at that time the quality of care and treatment was much more enlightened.

Archives at the Warwickshire County Records Office include annual reports in the Quarter Session minutes, along with many other documents about the Asylum (some of which are of course confidential). Occasionally, talks are given there about the life of the hospital: one such talk by local historian Julie Moores carried the title *Life in the Madhouse: Warwick County Lunatic Asylum.* She provided an insight into how the Victorians treated the mentally ill. The Hatton Records include admission notes, casebooks and photographs.

A former staff member says:

> Some of the treatments used might raise a few eyebrows nowadays. Malaria therapy for GPI (General Paresis of the Insane), produced a raised fever that disabled the organism causing the illness. This treatment had been abandoned by the 1960s because antibiotics proved more effective. LSD therapy was used for a short while ... ECT (Electro-Convulsive Therapy) or Insulin Therapy was used to treat depression ... and padded cells where violent patients could be left to calm down, but they were very rarely used.

St Michael's Hospital. (Author)

A–Z of Warwick

Court House

> Yes, here I tender it for him in the court...
> Bassanio in *The Merchant of Venice* (Act IV, Scene 1)

The historic Court House stands at a location formerly known as High Cross, midway between each of the town gates. In the centre of the crossroads here stood a significant stone cross, where proclamations were read out.

The building used to be the Cross Tavern in the sixteenth century and was one of the few to survive the Great Fire of Warwick in 1694. The Tudor kitchen in the basement now holds the Warwickshire Yeomanry Museum, and the wall recesses here mark where the barrels were rolled in from the pavement outside, during the days of the Cross Tavern. Another recess would have been the bread oven; there is also a large fireplace where cooking would have been done. Some of the flagstones on the floor are thought to be from the twelfth or thirteenth century. We do have records confirming the site to have been in use at least since 1340. Throughout the centuries, the property on this land has always either been in the ownership of the earl, the keeper of the castle, the Crown, or a royal servant.

Up until 1570, the burgesses of the town corporation (formerly known as the United Guilds), had conducted their business in Burgess Hall. In 1571, they moved to the Cross Tavern, under pressure from Sir Robert Dudley, Earl of Leycester, who wanted their hall as a home for his retired soldiers, henceforth to be known as the Brethren. He placed a master in charge of them and changed the name of the building to the

13. Front view of Court House. (Author)

Lord Leycester Hospital. So it was that the council eventually began to hold their weekly Wednesday meetings at the 'parlour by the Cross.' In 1628, they installed stairs to the upper rooms, before moving all their records there from St Mary's Church.

Sixty-six years later, the great fire destroyed a large part of the town centre, but the Court House was only slightly scorched. Nevertheless, in the frenzy of rebuilding that followed the fire, architect Francis Smith was commissioned to design a new Court House constructed in sandstone. Opened in 1728, it immediately became the fashionable centre of town life, with balls, assemblies, dinners, and public meetings, and soon became used as the Town Hall.

Finances from a 2019 Heritage Lottery Fund grant and from Warwick Town Council meant a major renovation could go ahead: stonework was improved, the Regency Ballroom received a new sprung floor, and a new kitchen was added. Along with this, the figure of 'Justice' on the building façade benefitted from a facelift, with gilding and carved coats of arms. Thanks to this careful historically accurate restoration, the subtle colours of the Georgian décor in the ballroom are true to the original.

The Court House is now well used for community events. The ground floor is occupied by the Visitor Information Centre, and the basement Tudor kitchen, as has already been noted, by the Yeomanry Museum. Warwick Town Council offices are also situated here, and on the first floor, the Council Chamber may be hired, as well as the ballroom.

The garden at the back of the building provides one of the many lovely green retreats to be found in and around Warwick. In the past, this belonged to Pageant House next door. A committee formed in the early 1900s to plan the 1906 Warwick Pageant in the castle grounds. The organisers used meeting rooms, workshops, and rehearsal space in Pageant House, as well as the gardens, all made available to them by the then owner

Regency Ballroom. (Author)

Edward Montague Nelson. The pageant raised sufficient funds to buy this garden for the townspeople of Warwick, and it became known as the Pageant Garden. The Court House remained as a magistrates' court until the First World War, when it was taken over as a government pay office; the Crown Court then occupied the Old Shire Hall in Northgate Street and is now to be found in Leamington Spa.

Rear of Court House building. (Author)

Pageant Garden. (Author)

D

Dungeon at the County Gaol

> Let me live, sir, in a dungeon, in the stocks, or anywhere, so I may live.
> Parolles in *All's Well That Ends Well* (Act IV, Scene 3)

Many Warwick residents are aware of the existence of a dungeon below our streets, but few have seen it, as it is not generally open to the public. The dungeon, which lies below the courtyard behind the ancient prison door in Barrack Street, may be accessed via the old part of Shire Hall. To reach it you pass through the passageways with the former prison cells, in use when the Crown Court was located here.

Once down there, the modern visitor may have good cause to reflect upon the inhuman way in which prisoners were treated in our nation in the seventeenth and eighteenth centuries. The dungeon is an octagonal room 18 feet 10 inches below ground and prisoners were brought down here at night to sleep on straw matting, with their feet chained to central posts, all arranged around a cesspit in the middle. When more than forty prisoners were brought down, they could only lie on their sides. The most recorded as being kept here one night was fifty-nine.

The dungeon would have been very cold and wet at times and liable to flooding as it is open to the elements via the grill high above the prisoners. This grill may be

Inside the dungeon – looking towards the steps. (Courtesy of David Robinson)

viewed in the courtyard of Old Shire Hall. Prisoners were last kept here just over 200 years ago, and one can imagine them lying on damp straw gazing hopelessly up at inaccessible freedom between the bars of the grill.

Those whose fate was to spend each night in this dungeon included not only hardened or hapless criminals, but also some Quakers and Anabaptists and individuals who simply held opinions the authorities didn't approve of. Also, deserters from the army were held here during the Napoleonic Wars.

A gaol was first built on the corner of Northgate and Barrack Streets in 1676, close to the site of the town gallows in the present Barrack Street, and four years later, the dungeon was added. Though the building was destroyed in the Great Fire of Warwick, it was totally rebuilt two years later. In 1719, the building contained eight chambers let to prisoners for rent, a women's ward, various chambers and garrets that were occupied by debtors, a debtors' hall and dungeon hall.

A long chain ran through the staples in the posts and through a link in the prisoners' chain, and then carried on up the steps, through the inner door, to be padlocked. In the morning, the prisoners were taken up out of the dungeon and held in a room at ground level. The courtroom is very close by. The dungeon's use declined over time. It ceased to be regularly used in 1797 after John Howard, the penal reformer, had visited it a year earlier and protested about the degrading conditions. Nonetheless, the dungeon was still used occasionally for army deserters.

The building known to us now as the Old Gaolhouse in Northgate Street ceased its use for that purpose in 1860, when the prison moved to The Cape, and for the next seventy years it served instead as a military barracks. After the barracks relocated to Budbrooke, some cells were kept, being used when prisoners were brought to Shire Hall on trial days.

The grill in the courtyard of the Old Shire Hall – below this grill lies the dungeon. (Author)

Earls of Warwick

> O Warwick, I do bend my knee with thine,
> And in this vow do chain my soul to thine!
>
> Edward in *Henry VI Part III* (Act II, Scene 3)

Throughout England's story from the Norman invasion on, the Earls of Warwick are never far from centre stage. At the end of the fourteenth century, it was said that you couldn't cross England from west to east without stepping on land owned by the Earl of Warwick. The earls wielded power through the centuries from the year 1088 with the creation of the first earl, Henry de Beaumont, who later changed his name to Newburgh.

In all, the title has been recreated four times; the first time in 1088, taking the earldom through the Newburghs, Beauchamps, Nevilles and Plantagenets. The second creation in 1547 covered the Dudleys. The third creation saw the Rich family take the title, though they didn't live at the castle. The fourth creation saw the title return to the Grevilles, who hold it to this day.

Henry de Newburgh's descendants lived at the castle for the first few centuries and began upgrading the castle from wood to stone. The 8th Earl of Warwick, William Mauduit, came into conflict with Simon de Montfort at Kenilworth Castle during the Barons' War. After William's death, the castle went to his nephews the de Beauchamps, who built the huge medieval towers. Regarded as England's greatest knights, they fought alongside their king and were rewarded with money, land and titles. Ransoming off high status prisoners was a family business. In 1369, Thomas fell victim to the Black Death and was buried with his wife Catherine in St Mary's Church in town.

The Beauchamps' family fortune was immense by the time the castle passed into the hands of Richard Neville along with the title of 16th Earl at the age of eleven in 1449. Richard played a central role in what later came to be known as the Wars of the Roses, but at the time was called the Cousins' War. He alternately raised up to the throne and then betrayed two of his cousins – more of that in my chapter on 'the Zenith of the Kingmaker's career'.

Caesar's Tower viewed from the castle courtyard. (Author)

Richard Beauchamp's tomb in the Beauchamp Chapel, St Mary's Church. (Courtesy of Jamie Robinson)

Finally, Richard was called to account by one of those betrayed cousins, Edward, in conflict at the Battle of Barnet in 1471, where Richard met his end. After his death, his daughter Anne was married off to Edward's brother Richard, Duke of Gloucester. He later became Richard III and started building two more towers on the other side of the courtyard, but did not have enough time during his two-year reign to finish the project. With his defeat at the Battle of Bosworth in 1485, Henry VII triumphed, winning the war, the throne and the castle. Sadly, Henry hated the place: grim reminders of his enemy Richard III kept him well away from it, so it fell into disrepair and remained that way until after the Tudor period.

For 118 years, the Tudor monarchs allowed the castle to crumble. The Crown left the title Earl of Warwick to the Dudley family, but the title expired with the death of Ambrose. When James I acceded to the throne, he needed a powerful English friend. In 1604 he gave the castle to his court poet and playwright Sir Fulke Greville, who became 1st Baron Brooke and moved in.

Sir Fulke loved the place and spent the equivalent of £8 million in today's values rebuilding the ruin into what we see today. He was murdered by his manservant and left the castle to his cousin Robert Greville, 2nd Baron Brooke, a Parliamentarian commander during the Civil War.

With the death of Robert Greville, killed by a sniper during a battle at Lichfield Cathedral, his widow handed over the castle to Oliver Cromwell. At the restoration of the monarchy, Charles II reinstated the Greville family at the castle, and from 1660 they began restoring it. By 1759, the title of earl had returned to them with Francis Greville, who had already started converting the castle into a grand stately home.

By 1804, the Grevilles had run up, in today's values, £13 million in debt; to pay it off, they opened their home to tourists in 1815. They carried on spending; to improve the family finances, the 7th Earl Charles became a film actor and was dubbed the 'Duke of Hollywood'. He was the last earl ever to live at Warwick Castle, and he has also been dubbed 'Warwick the Filmmaker'.

The Grevilles hung onto the castle until 1978, when David, son of Charles, sold it to the Tussauds Group. In 2007, Tussauds transferred the castle, contents and grounds to Merlin Entertainments, who now look after it for the many who visit all year round. David's son currently holds the title, and the castle flourishes in the hands of Merlin. It's still standing 954 years after first being built by William the Conqueror.

A–Z of Warwick

East Gate

> ...alone he entered
> The mortal gate of the city.
> Cominius in *Coriolanus* (Act II, Scene 2)

Guarding the east side of the town of Warwick, this gate was built in the eleventh century over a massive wall of rock. The small chapel of St Peter on top is a medieval foundation dating to 1426, early in the reign of Henry VI, when it was maintained by the Guild and many masses were sung there. The chapel was ruinous by 1571 and the Corporation acquired it five years later. It survived, though much altered and in a deteriorating state, until its restoration in the late eighteenth century.

East Gate and the Chapel of St Peter. (Author)

E

The architect Francis Hiorn, three times mayor of Warwick, loved experimenting with the Gothic style. In 1788, the present building was opened, with classic symmetry and Gothic details. The following year, the King's High School for Girls moved into nearby Landor House, and the chapel became part of their school, providing extra classroom space for the sixth form. The school flourished and expanded there for 140 years before it moved to its new Banbury Road site in September 2019.

The East Gate is listed as a Grade II Scheduled Ancient Monument, and today, you may only see inside the chapel if you book a few nights there, for it is now in private ownership under the watchful eye of English Heritage and rented out as holiday accommodation.

Eagles at Warwick Castle

> Coming from Sardis, on our former ensign
> Two mighty eagles fell; and there they perched.
>
> Cassius in *Julius Caesar* (Act V, Scene 1)

The eagle has, since ancient times and in many cultures, embodied might, regality, and ferocity to humankind. This significance did not escape the Earls of Warwick. Richard Beauchamp, 13th Earl, from 1382 to 1439, is known to have employed a falconer called Lewis as an important and well-paid member of the household. Falconry was extremely popular among the nobility at that time: Lewis had two assistants to help

Eagle flying in the castle Falconer's Quest. (Author)

keep and maintain the birds of prey. Today, ten different bird species feature among the collection at the castle, ranging from Andean condors to peregrine falcons, bearded vultures and three eagle species – the white-tailed eagle, the Steller's sea eagle, and the North American bald eagle. They all perform at the Winter Bird of Prey show and in the summer at the Falconer's Quest.

The so-called 'bald' eagle is the national bird of the USA. These birds are not actually bald: the name comes from an older meaning of the word, 'white-headed'. Henry has a dark body and wings, and a white tail. It takes five years for bald eagles to get their beautiful white feathers: Henry is now five years old, with a 6-foot wingspan, and on the team of working birds. He is the fifth of seven chicks from Archie and Sidney, stars of the show in previous years. At the time of writing, Archie is twenty-nine years old and Sidney is thirty-eight – North American bald eagles can live to the age of fifty. Neither bird currently works on the display team, but instead enjoy their retirement, being well fed at the castle.

The young birds are trained at a special base up in Yorkshire, so they have all the room they need to learn to fly properly at Warwick Castle. For Henry, along with the other birds of prey, flying in windless conditions is hard work; in his ideal conditions, he swoops and cruises on the south-westerly wind currents blowing across the River Avon from the River Island, up the hill towards the Mound. But he works to a high

Falconer with eagle. (Courtesy of Abigail Robinson)

standard in all conditions, as he is well paid with plenty of fresh food, and an expert at catching it in mid-air, tossed up to him by the falconer. Thus, he and the other eagles continue to captivate us with their vision and concentration; and maintain their formidable hold upon our imagination.

Henry the eagle flying at the castle. (Courtesy of Jamie Robinson)

Folk Festival

> ...but till 'tis one o' clock,
> Our dance of custom round about the oak
> Of Herne the hunter, let us not forget.
> Hostess Quickly in *Merry Wives of Windsor* (Act V, Scene 5)

The tradition of folk dance and song has through the centuries been the primary form of expression for people in keeping their culture alive by telling and singing their stories rooted in the past but persisting into the present. Therefore, folk songs are a precious resource for recording their history. Warwick Folk Festival celebrates traditional and contemporary folk arts each year on a summer's weekend. At the time of writing, it has been running for forty-one years, not including the pandemic years of 2020/21, and traditionally has everything from ceilidhs, song and dance, workshops, theatre, crafts, the Folk Festival Choir and many more activities for the whole family.

Folk singers, dance troupes and musicians from all around the UK descend upon Warwick in July. The grounds of Warwick School have in the past been the site of this vibrant festival, but in 2022, on the weekend of 21–24 July, the castle park became the new venue for the festival. Also, traditional musicians and dancers perform in the town's Market Square.

In 2022, the festival showcased several top folk singers on the Jester Stage, including Will Hampson, melodeon player and dancer, and Bryony Griffith, fiddler and singer; this husband-and-wife duo are considered to be 'two of England's finest interpreters of traditional English music' and received high acclaim for their first album together, *Lady Diamond*. With subtle nuancing and sensitive dynamics, the pair interpreted a range of English folk songs for us, from despairing laments to bright celebrations. Bryony told us one of the things she loves doing is going round old churchyards finding folk song graves. The lyrics of one of the songs, about the five ringers of Egloshayle, are inscribed around the belltower of St Petroc's Church at Egloshayle, Cornwall, and the memorials of 'those five ringers bold' (who are all named in the folk song) may be found in the churchyard.

F

The festival's new location in Castle Park brings all the principal venues and camping together onto one site together with a variety of food and drink vendors, a general store, craft fair and instrument stalls. Performances by other headline acts and internationally renowned multi-instrumentalists take place in seated marquees and in the Ceilidh Tent.

Bryony Griffith and Will Hampson performing on the Jester Stage at the Warwick Folk Festival, 2022. (Courtesy of Jamie Robinson)

G

Great Fire of Warwick

> Whose words like wildfire burnt the shining glory
> Of rich-built Ilion, that the skies were sorry.
>
> *The Rape of Lucrece*

In medieval times, Warwick was a town of narrow streets and jettied timber houses with thatched roofs. The proximity of the houses to each other can be seen in Castle Lane. The potential for devastating fire in such towns was always present: the Great Fire of London had taken place twenty-eight years earlier, in 1666. Yet no major fire had broken out in Warwick until three other fateful conditions came together to create disaster. A 'potboy' from the tavern in the building now known as Lord Leycester Hospital crossed the road to get a knife. A strong wind was blowing up West Street, and took a spark from his candle, which flew on to a thatch and started the blaze. It had been a long hot dry summer, and the blaze soon spread.

View of narrow Castle Lane – all streets in medieval Warwick were as narrow as this before the 1694 Great Fire. (Author)

The fire engulfed all the wooden houses from the site of the present Quaker meeting house, up the high street until it reached the crossroads, when the wind turned and the flames raged up Church Street instead, towards St Mary's Church. The terrified townspeople fled with as many of their belongings as possible, and a gentleman called Dr Johnson, down in Jury Street, ordered his neighbour's house to be destroyed to create a firebreak. Later, he discovered it had been unnecessary as the fire never reached his house. The flames crossed Church Street, destroying houses on both sides and about half the length of the north side of Jury Street until halted by a stone building. Dr Johnson had to hand over £6 to cover his aggrieved neighbour's rebuilding costs.

Meanwhile, the townspeople had fled to the church for sanctuary, but their belongings were smouldering, and the church caught fire too. The bell melted and fell to the ground. With a valiant community effort, and a good supply of water, the townspeople saved the Beauchamp chapel; the fire was contained, thus sparing the buildings in Northgate Street, where the Shire Hall contained many irreplaceable papers.

Quaker Meeting House and half-timbered house next to it showing where the fire started. (Author)

The Beauchamp Chapel at St Mary's Church. (Courtesy of Jamie Robinson)

View of the 1696 house from ballroom window. (Author)

A document stored in Warwick County Records Office provides evidence that Fulke Greville, 5th Lord Brooke, called a meeting of the wealthy townspeople the day after the fire, on 6 September, and asked them to contribute to the rebuilding fund. An Act of Parliament was passed to control the rebuilding programme, in which it was ordered that all buildings be made of stone, with roofs of slate, to be no more than two storeys high, although they could have dormers and cellars, and that all the roads be much wider. It is this Act, together with the high calibre of the architects and building standards, that ensured we have today a town centre filled with so many beautiful houses. Many of them were rebuilt using the local Triassic sandstone, particularly for the more important public buildings. The rebuilding was well under way by 1696.

Globe Hotel

> What, will you walk with me about the town,
> And then go to my inn and dine with me?
> Antipholus of Syracuse in *The Comedy of Errors* (Act I, Scene 2)

First opened in 1788 as the Globe Inn Commercial and Posting House, this hotel, situated on Theatre Street between the castle and the Market Place, became a theatre in the early 1800s. Within this Grade II listed building, many pantomimes and plays were performed, and this gave the street its name. Until the 1960s, the theatre was accessible via an iron bridge spanning a ravine-like street named The Holloway. The topography of the area has changed considerably since then. The Globe now houses an extensive bar, lounge and restaurant, as well as an eighteen-room hotel.

G

The Globe Hotel. (Author)

Guildhall

> I go; and towards three or four o' clock
> Look for the news that the Guildhall affords.
>
> Buckingham in *Richard III* (Act III, Scene 5)

The Guild of St George was formed under licence from Richard II in 1383 thanks to the patronage of Thomas Beauchamp, who granted them the Chapel of St James over the West Gate. Before 1413, the Guild of the Holy Trinity and the Blessed Virgin had moved from St Mary's Church and combined with the Guild of St George to become known as the United Guilds. They have been described as 'self-help groups', looking after not only the spiritual but also the physical needs of their members and of the town. In 1450, to cater for their growing role, Richard Neville built a series of timber-framed buildings to the north of the West Gate and the rebuilt chapel, and these survived both the Dissolution of the Monasteries in the 1530s and the Great Fire of 1694.

The survival in the 1530s was the result of quick thinking by Thomas Oken, then Master of the Guild. Along with all other religious guilds, this one in Warwick would have fallen victim to Henry VIII and his Commissioners during the Dissolution of the Monasteries. However, Thomas Oken came up with a plan: he transferred the guild into the control of the townspeople so it could no longer be considered a religious guild, but the town corporation instead. By this clever move, he saved all their property.

For a while the buildings continued to be used under the name of Burgess Hall for borough business, but in 1571, as we have seen, Robert Dudley, Earl of Leycester, took over the building and founded his charity there for a community of brethren, who had fought in Her Majesty's wars. Dudley appointed a master to run his charity and over the centuries since, thirty-three masters have continued this proud tradition. The current master, Dr Heidi L. Meyer, is overseeing a major renovation project at the time of writing.

Lord Leycester Hospital. (Author)

Within this fine quadrangle of medieval buildings, the oldest, the Great Hall, was built on the west side probably soon after the formation of the Guild of St George. The Great Hall continues a 600-year record of hosting public functions. The east range contains the Brethren's Kitchen on the ground floor and the Priest's Dining Room above. The Master's House takes the north side of the courtyard. This beautiful building will be transformed into a museum by 2023.

Another hall on the first floor occupies much of the south side. This, the Guildhall, was probably built fifty years later than the Great Hall and used exclusively by members of the guilds. The room was primarily used as a private chamber where they met to discuss the day-to-day running of their affairs, but when the hospital was founded, Robert Dudley had it divided into four apartments. It wasn't until 1950 that the Guildhall was returned to its original gracious proportions that we admire so much today.

Great Hall, Lord Leycester Hospital. (Courtesy of Jamie Robinson)

G

Master's House at Lord Leycester Hospital. (Author)

Guildhall at Lord Leycester Hospital. (Courtesy of Jamie Robinson)

Greatheed Family

> Indeed, to speak feelingly of him, he is the card or calendar of gentry, for you shall find in him the continent of what part a gentleman would see.
>
> Osric in *Hamlet* (Act V, Scene 2)

The Greatheed family of Guy's Cliffe have had a significant influence on the development of Warwick and Leamington Spa for over 300 years. Samuel Greatheed was born in 1710, the son of John and Frances Greatheed of St Mary Cayon, on the Caribbean Island of St Kitts. Educated at Bradford and then at Trinity College Cambridge, he married Lady Mary Bertie on 21 February 1748. After rejoining his family in St Kitts for a few years, he settled in England.

He first came upon the land by the River Avon in 1743 and leased the property that year. Income from the St Christopher Plantation in the West Indies bolstered Greatheed wealth, which means he had amassed his wealth through the international slave trade. With this wealth he purchased and began a programme of improvements at Guy's Cliffe in 1750. Four years later he was elected MP for Coventry.

> The Guy's Cliffe estate paid tax on over 230 slaves in the early 1780s. Lady Mary Greatheed ... commissioned a large lead statue of a kneeling enslaved African bearing a sundial on its head, which stood in the driveway until it was removed in the 1940s.

Samuel and Mary's son, Bertie, was born in 1759. The adult Bertie, to his credit, with his 'Enlightenment' ideals, later decried slavery, but he still couldn't avoid the fact that his family had benefited from it and would continue to do so. Following his father's early death in 1765, when Bertie six years old, he was placed under the guardianship of members of his mother's family. He finished his education in Germany, and it may have been there that he developed his taste for foreign travel. When he was twenty-one, he married his first cousin Ann, and their son (also called Bertie) was born the following year.

> He was a colourful Enlightenment squire who travelled in Europe, made his own wine, dabbled in literature, opposed blood sports, championed religious dissent, and was horrified at the conditions of workers in the local textile factories at Saltisford: a typical Whig landowner of the period. His illustrious friends included the actress Sarah Siddons, the classical scholar Samuel Parr, and the essayist Walter Savage Landor.

Bertie was interested in the arts and wrote poetry. He was also a great diarist, and his diaries are now held in the Warwick Record Office, a testament to his character and a precious resource for historians. He and Ann took their young son on a grand tour of Europe from 1782 to 1786 and made several other visits to the Continent including in 1803 where the family, along with many other British visitors, were held as prisoners of war in Paris. During this time, they became acquainted with Napoleon Bonaparte along with many other members of British and French society. They were allowed to leave Paris only on the condition that they did not return to England, so they went via Dresden to Italy, where tragedy struck: their son died of influenza at the age of twenty-three.

Devastated by their loss, Bertie and Ann retired to Guy's Cliffe in 1805, taking their newly discovered grandchild with them (for the full story of this see my chapter on Inheritance). Bertie became a great local benefactor, using his fortune to support many projects and good works. It was also from this time that he put his greatest efforts into the development of the house and its gardens.

The walled garden had provided food and flowers for the house from around the 1740s and continued to do so up until after the Second World War when the estate was broken up. The Victorians were known to be great collectors of ferns, and a traditional Victorian fernery amongst tree stumps occupies a shaded and damp part of the garden today.

200 years after Bertie first planted his new varieties of apple tree, with a grant from the King Henry VIII Charity and the establishment of a community volunteer project, the Guy's Cliffe historic walled kitchen garden has been fully restored. Dedicated

gardeners have planted the same varieties in the same positions as he did back in 1811, and the garden has been returned to its former Georgian and Victorian glory.

How he ensured that his estate passed into good hands despite the tragic loss of his son is told in the chapter on Inheritance.

Guy's Cliffe House, *c.* 1800. (Public domain)

Information noticeboard in Guy's Cliffe Historic Walled Garden. (Author)

Guy's Cliffe Historic Walled Garden. (Author)

Hatton Locks

> Fortune brings in some boats that are not steered.
> Pisanio in *Cymbeline* (Act IV, Scene 3)

For those in Warwick who are fascinated by canals, a trip out to Hatton Locks is sheer delight. Visitors may park for the day and may then walk along the towpath in either direction or stroll across the bridge, pause to admire the view towards the town along that famous 'stairway to heaven' of twenty-one locks, and the Gothic tower of St Mary's Church at the far end of the vista.

Then they may continue the canal path in the direction of the café or choose to spend hours watching the colourful narrowboats as they move through this flight on the Grand Union Canal. It almost becomes mesmerising: you may forget everything else going on in your life as you become lost in the joy of watching the boats make

Hatton Locks. (Author)

H

View from the bridge at Hatton Locks to St Mary's Church. (Author)

their unhurried progress through the locks, an experience which lifts visitors out of their everyday world and into the 'parallel world' of the waterways.

This 'parallel world' began to come to fruition in 1793 in this area when an Act of Parliament authorised the construction of the Warwick and Birmingham Canal. The route started from the Digbeth Branch and the twenty-one locks were needed at Hatton to drop the canal, which originally terminated at Saltisford Wharf, just outside the town centre.

Hatton Locks first opened in December 1799. The locks cover 2 miles, and an experienced boater takes four to six hours to pass through them. On the day the locks were opened, bands played and crowds gathered to watch the Duke of Kent arrive by boat and cut the ribbon.

The locks gained their name 'stairway to heaven' in rather a curious way: although it may be tempting to interpret this name very differently, the prosaic explanation is that those in the waterways fraternity came up with the name because of the hard work involved in the ascent, followed by an easy run to Camp Hill, where the workers were paid.

However, the waterways met with too much competition from the growing railway network, and this was becoming very clear by 1839. Ninety years later, the Warwick and Birmingham Canal including the Hatton Locks became part of the Grand Union Canal, and soon after that, the Hatton Locks were converted into weirs and a new wider flight constructed, adjacent to their original counterparts. Today, as we also admire the heritage listed lock-keeper's cottages, our enjoyment of the canal for leisure purposes is enhanced by the work of the Canal and River Trust, who care for all the inland waterways in England and Wales.

Hill Close Gardens

> Thy promises are like Adonis' gardens,
> That one day bloomed and fruitful were the next.
> Charles, King of France, in *Henry VI, Part I* (Act I, Scene 6)

Next to Warwick Racecourse, Hill Close Gardens may be found, the only group of restored detached Victorian gardens in the country. During my visits, I have always felt they have a very special atmosphere. For those who walk down the path between the hedges that enclose each plot, and then explore the gardens themselves, we can almost believe that our presence there is by personal invitation of the nineteenth-century gardeners, who, together with their families, took so much pleasure from them, and for whom this was a tranquil retreat away from the cares of everyday life. The summerhouses have been furnished and equipped as if time had rolled back and we are stepping into the Victorian era. Research, too, has uncovered the stories of several of the original owners of the plots.

In the 1800s, shopkeepers and skilled artisans were independent tradesmen who owned or rented town premises and whose families lived above the shop. Each household would have a backyard filled with a workshop, wash house, privy and stable, leaving no room for a kitchen garden. Tradesmen who wanted to cultivate fruit, vegetables and flowers looked for a plot to rent, many of which were commonly found on the edges of crowded towns before suburban development covered them. They were known as 'detached gardens'.

In 1845, Hill Close pastureland was divided into garden plots, which Warwick tradesmen rented. They planted apple trees and soft fruit, grew vegetables and flowers, kept pigs and poultry, and built summerhouses of brick or wood to shelter from rain or to sit and enjoy the view across the Common.

Later, the freeholds of these plots were purchased individually, though some were then sub-let. As times changed and more people came to live in houses which had gardens attached, the use of these special hedged gardens diminished. They fell into disuse and were overgrown and became derelict. In the early twentieth century, part of Hill Close Gardens was sold off for housing.

In 1994, a Warwick pressure group managed to get four summerhouses listed as Grade II. After historical research, those local activists together with English Heritage persuaded the council to let planning permission lapse and restore the gardens instead. In 2000, Warwick District Council helped set up a trust to manage and restore the site, in which all gardens and historic structures are now Grade II listed.

The Warwickshire Group is one of the few groups involved in the conservation of historic gardens and has played a significant role in restoring those at Hill Close. It maintains Heritage Garden Plot Seventeen to grow plants received through the Plant Exchange, which identifies, propagates and distributes cultivated plants at risk of extinction. Special events are held in the gardens at different times of year, such

as 'Apple Day' when creative activities are offered for children. A new visitor centre built with a Heritage Lottery grant is hired out to local organisations for events. These gardens, tended by a devoted team of volunteers all year round, have become a celebrated and much loved part of Warwick, next to the Racecourse.

Hill Close Gardens. One of the plots showing a summerhouse. (Author)

A view from inside a summerhouse, out through the window into the gardens. (Courtesy of Abigail Robinson)

Inheritance

> When the man dies, let the inheritance
> Descend unto the daughter.
> Archbishop of Canterbury in *Henry V* (Act I, Scene 2)

Bertie Greatheed, as we have seen in an earlier chapter, was a flamboyant diarist and playwright and he was also an architectural designer. After he and his wife Ann welcomed their son, also named Bertie, they must have been delighted to see him grow up to share his father's passions: travelling and art. Bertie Junior accompanied them on their continental travels. But tragically, the talented young artist died of influenza in Italy in the year 1804, at the age of twenty-three, causing great anguish to his parents. Bertie senior and Ann had no other children, so the recently deceased son was their only heir.

Then they discovered that their son had claimed to have secretly married whilst in Italy, but no documentary evidence existed for this. Rather, it seems that Bertie Junior had entered a liaison 'with a woman of low birth' in Dresden, and no marriage had taken place. They learned that a baby girl had been born to the couple earlier that same year and found the child, called Ann Caroline. Bertie and Ann adopted her and brought her back to Guy's Cliffe.

Ann Caroline, who had begun life with her mother in Dresden, clearly thrived in her new surroundings and as she grew older her fortune began to attract suitors. She eventually married Lord Charles Percy, son of Algernon Percy, 1st Earl of Beverley (a nephew of the Duke of Northumberland), on 3 March 1822. However, according to some accounts, her 'low birth' made her the subject of unkind comments.

Ultimately, she inherited the entire estate of Guy's Cliffe at the age of twenty-two, four years after her marriage to Charles Percy.

> History does not look entirely kindly on Charles who was seen by some as marrying Ann Caroline for her money and was said to have led 'a largely aimless life'. He had taken up government appointments abroad before becoming a member of

parliament and serving in Ireland. In 1865, when his brother became the 5th Duke of Northumberland, he became Lord Charles Percy. He died in 1870 while staying at Alnwick Castle and is buried in the family vault in Old Milverton parish church.

Ann Caroline seems to have inherited her grandfather's love of Guy's Cliffe and was very successful at local horticultural and flower shows with her gardener Manuel Elliot, who worked in the kitchen garden, now restored as we have seen, and open to the public as Guy's Cliffe Historic Walled Garden. Ann Caroline also inherited Bertie's philanthropic nature and was associated with many good works in the local area. It was she who commissioned the stained-glass window in St James's Church, Old Milverton, Leamington Spa, in memory of a lifetime's service by William and Samuel Squires as stewards to the Guy's Cliffe estate. At the time of her death on 4 March 1882, it was said that she 'enjoyed a wide reputation for gentleness and benevolence'.

Her destiny could have been so different in those times, being female, illegitimate, and of so-called 'low birth' on her mother's side, thus opening her to the harsh judgement of society. Her tombstone may be found at the churchyard of St James the Great at Old Milverton, just across the field from the ruins of the mansion. You may stand beside her grave and gaze down the hill to the mansion and the estate she owned.

The inscription on Ann Caroline's tomb at Old Milverton churchyard. (Author)

A–Z of Warwick

Ichthyosaur

> How long is this ago?
> Second Gentleman in *Cymbeline* (Act I, Scene 1)

Warwick Market Hall Museum includes several intriguing fossil specimens in its current display and one of these is the skeleton of a 200-million-year-old ichthyosaur collected during the nineteenth century from a quarry at Wilmcote, near Stratford-upon-Avon. Ichthyosaurs were marine reptiles that lived during the Mesozoic era; in the Jurassic they reached their highest diversity, then began to decline. They became extinct in the Cretaceous, several million years before the last dinosaurs died out. Their name means 'fish lizard'.

Warwick Market Hall Museum. (Courtesy of Jamie Robinson)

Ichthyosaur in Warwick Market Hall Museum. (Author)

42

Numerous interesting and unusual fossils have been found in the Wilmcote quarries, partly due to the hand-working methods. The quarries are no longer in work, and most have been infilled. However, one of them is protected as a Site of Special Scientific Interest, for the limestones here represent 200-million-year-old mud, deposited on a shallow seafloor that covered Warwickshire at the dawn of the Jurassic Period.

This is the skeleton of a small ichthyosaur which had not yet reached full maturity. How this creature died is unknown, but its body must have been very rapidly entombed within the mud. When we gaze at fossils like this, saved from destruction and presented for our viewing, we feel a greater sense of awe at the profound changes our planet has undergone over the millennia. This encourages us to reflect upon life and the environment, and enables those who spend time in the museum to visualise how the land now occupied by Warwick may once have looked.

Incarcerations

> My liege, I did deny no prisoners.
> Hotspur (Henry Percy) in *Henry IV Part I* (Act I, Scene 3)

Several high-ranking prisoners were kept in Warwick Castle from the time of the Beauchamp family right through to the end of the English Civil War. The Beauchamps, regarded as England's greatest knights, held the castle for nearly 200 years, from 1268 through to 1449. Favoured by the kings for whom they fought, they used their immense wealth to build the two medieval towers including Caesar's Tower, known in the mid-1300s as Poitiers Tower. This is where they would incarcerate prisoners. In battle the Beauchamps would capture high-ranking individuals, keep them in good conditions high up in that tower, and then ransom them back again for fabulous sums of money.

In the mid-1300s, Thomas Beauchamp was fighting in the war in France; his exploits there earned him the nickname 'the devil Warwick' from the French. He captured the Archbishop of Sens at Poitiers, brought him to Warwick, kept him up in Poitiers Tower, and ultimately sold the archbishop back to France for £3 million (by today's reckoning). This was the largest ransom of the fourteenth century and gives us a good sense of how the Beauchamps amassed their huge wealth. However, the Black Death put an end to Thomas's illustrious career as we learned in the chapter on the earls.

The most famous prisoner is considered to have been Edward IV, in the year 1469, when Richard Neville had decided to depose him. Edward was kept prisoner for a week in the highest room of Caesar's Tower. Richard held him under lock and key for two or three months in total, but for most of that period Edward was incarcerated elsewhere. Richard, however, didn't enjoy enough parliamentary support, so eventually he was forced to release Edward, thereby giving his former prisoner the chance to take

A–Z of Warwick

revenge. This Edward did at the Battle of Barnet, duly regaining his throne upon the death of Richard on the battlefield.

Edward Disney was Walt Disney's ancestor and he found himself under lock and key in Warwick Castle in March 1643 during the English Civil War, awaiting execution, having been captured at the Battle of Edgehill by the Parliamentarian army. During his time incarcerated in a hidden part of Guy's Tower, he engraved his surname into an arrow slit within the prison's living quarters. Below his name was etched the name of William Stanely, hinting a date of 23 March, possibly 1643. Because he was a noble his life was spared, and he was sold back to his family by Oliver Cromwell for a huge ransom.

Caesar's Tower from Mill Street. (Author)

Judges' House

> By learned approbation of the judges.
> Cardinal Wolsey in *Henry VIII* (Act I, Scene 2)

The Judges' House was built in Northgate Street in 1816 to provide accommodation for assize judges serving at the courts, housed in the adjacent Shire Hall building, and as a meeting place for the Warwickshire Justices of the Peace. Anyone taken on a tour of the prisoners' cells behind these lofty and gracious rooms will receive a sharp impression of the utterly different world in which the Judges moved. Those they would be judging endured a wretched time in grim cells very close by. The contrast between wealth and status, and the miserable lot of those who had fallen foul of society could hardly be stronger.

Henry Hakewill, a notable Greek Revival architect, had designed the building. He is also renowned as architect to Rugby School, the Radcliffe trustees in Oxford and to Middle Temple, designing buildings for all these locations in the first three decades of the nineteenth century.

In 1955, when the Warwickshire County Council offices to the rear of the building were expanded to provide a new council chamber, the rear wing of the Judges' House was demolished, but the rest of it continued in its original use up to 2010. Today, together with the Old Shire Hall, it opens to the public just once each year in September, on Heritage Open Day, when visitors may view the grand interior.

On display is the historical portrait collection, and visitors may view the octagonal courtrooms and the Sheriff's Room. With its lofty Regency-decorated rooms, including mouldings and fireplaces, it is a magnificent space. The spectacular Grand Hall has stone columns, a beautiful ceiling and period chandeliers, and the Judges' Dining Room and Drawing Room are both entered via a sweeping staircase. The two courtrooms with their elaborately decorated high-domed ceilings and Corinthian columns served as Crown and County Courts following the Court Act of 1971, with Crown Court sessions held there up until 2010, when they moved to nearby Leamington Spa. Both the Judges' House and the Old Shire Hall are mostly used now for weddings, business conferences, meetings, fine dining, ceremonies, and other events.

Judges' House, Northgate Street. (Author)

K

Kingfisher Pool

> In a great pool, a swan's nest.
>
> Imogen in *Cymbeline* (Act III, Scene 4)

St Nicholas Park on the southern edge of town was formerly known as St Nicholas Meadow, until the Warwick Borough Council purchased the site in the 1930s and went on to lay out a beautifully landscaped park beside the river. The two period cottages near the car park were originally a watermill. Now the park has sports and leisure facilities, a children's playground, funfair, paddling pool, boathouse, and café, along with exquisitely laid-out gardens, a variety of fascinating trees, and views across to the castle.

After the Second World War, the ground to the east became playing fields. Over at the south side of the park lies the Kingfisher Pool, a tranquil retreat with ideal facilities for angling for children and adults. Thirty-seven platforms are placed at regular intervals around the lake, accessed by a public footpath for walkers and cyclists. The pool is stocked with several different types of fish and is a safe place to take up the sport of angling in a beautiful wildlife haven. There are special permits to fish for children and for senior citizens. Around the pool wild rabbits, and many species of birds, plants, and insects may be seen.

Kingfisher Pool, St Nicholas Park. (Author)

Leper Hospital

> There is no leprosy but what thou speakest.
> Apemantus in *Timon of Athens* (Act IV, Scene 3)

All who pass through Saltisford will see the old chapel and dilapidated historic house nearby. Together, these two structures are all that remain above ground from the last leper hospital in England, representing a rare survival from the time before the Dissolution of the Monasteries, when Warwick contained many religious buildings. These included not only parish churches and chapels: by the twelfth-century St Sepulchre's Priory had been built, and three hospitals, of which St John's was one, and the other two were hospitals for lepers – St Lawrence's, and this one at Saltisford, St Michael's. A Dominican friary was started in the 1260s, and in Bridge End St Helen's chapel and hermitage could be found. Virtually nothing survives of any of these establishments above ground today except for these two buildings at Saltisford. The small stone chapel was much in ruins in the 1540s. Later incorporated into an eighteenth-century cottage, it has now been restored. Close by is the fifteenth-century two-storey Master's House.

Roger de Beaumont, 2nd Earl, founded the original St Michael's Leper Hospital in 1135. The chapel and house we see today are contemporary with the later medieval development of the site, both being classified Grade II by English Heritage as a Scheduled Monument. Warwick District Council made a Compulsory Purchase Order in 2021, and have published their plans to conserve, repair and alter the Master's House, and redevelop and improve the site.

The future appearance of the site has been envisaged by an artist, showing attractive landscaping. Upon fulfillment of this project, it will be a pleasure to look at for all who pass by, as well as to live in – for the fortunate purchaser of the Master's House once it is converted into a two-bed dwelling with all modern facilities. The proposals also include the construction of a new three-storey apartment block to the north of the site, which hopefully will not detract from the historic buildings but enhance the site.

L

Right: The old chapel, formerly part of the medieval leper hospital at Saltisford. (Author)

Below: The old Master's House, formerly part of the medieval leper hospital at Saltisford. (Author)

M

Master's Garden

> I'll fetch a turn about the garden.
>
> Queen in *Cymbeline* (Act I, Scene 1)

Hidden behind the ancient buildings of the Lord Leycester Hospital we may find the enchanting Master's Garden. This historic plot, enclosed by the town wall of Warwick, has been cultivated for over 500 years and was restored in the 1800s and again in the 1990s.

Robert Dudley, Earl of Leycester, acquired the buildings, orchard, and garden in 1572, and established a home for retired soldiers there. He decreed that the lower half of the garden be left 'green-sward for recreation'. In 1852, the lower half was restored to its original condition and use. Here the brethren played bowls and billiards. The twelfth-century Norman arch between the magnolias was discovered under the Chapel of St James over the West Gate during the restoration of the chapel in 1860 and was re-erected in its present location.

The huge stone vase is reputed to be a 2,000-year-old 'Nilometer', which crowned one of the columns that stood on the banks of the Nile, used for measuring the height of the river's floods. This was the basis for levels of annual taxation on agricultural land. Visitors to this glorious garden include Nathaniel Hawthorne in 1855, and at other times, Charles Dickens, Charles Darwin, and Oscar Wilde.

The Master's Garden behind Lord Leycester Hospital. (Courtesy of Jamie Robinson)

The twelfth-century Norman arch and the giant stone urn in the Master's Garden. (Courtesy of Jamie Robinson)

Mill Garden, Mill Street

> Should not in this best garden of the world ... put up her lovely visage?
> Duke of Burgundy in *Henry V* (Act V, Scene 2)

This exquisite garden on the banks of the River Avon is to be found at the bottom of Mill Street, an enclave full of fifteenth- and sixteenth-century houses. From this garden visitors may see breathtaking views of the south side of the castle and Caesar's Tower; of the river and the ruined medieval bridge; and of the castle mill and engine house. This garden is sited at the point where medieval travellers from the south had just crossed the bridge and now approached the toll booth to pay their dues before entering Warwick.

The garden was originally created over a period of sixty years by a colourful local character called Arthur Measures, who was manager of the main Birmingham branch of Barclays Bank. His garden is famed for the quality of its planting, and he made it a personal expression of his love of plants. Arthur would open his garden to the public at the start of the summer season, and visitors would put their donations into his collecting box. By the time the garden closed at the end of the season, the homemade collecting box was expected to have gathered £100,000 for charity. Arthur reached the age of ninety; he had lived in the town from childhood, and together with his wife Violet he became famous for his garden.

A–Z of Warwick

Born in Manchester, as a one-year-old baby Arthur moved into the Warwick workhouse with his parents, who were master and matron and brought up a family of six there. He saw a system which would have been familiar to Dickens and how easily poverty could tip decent people into destitution. He married Violet in 1936, and they moved into the cottage at the end of Mill Street and started planting. They made a cottage garden on an exuberant scale, framing the picturesque views. It was originally opened for one weekend to raise money to restore the St Mary's Church tower. Gradually Arthur and Violet acquired a string of other charities and eventually their garden opened from Easter to October.

Arthur took early retirement from the bank after forty-two years because of ill health and died close to the garden he loved. His son and daughter David and Julia have established a fund to preserve the garden and keep it open in his memory.

Above left: Mill Street cottages viewed from the castle battlements. (Courtesy of Abigail Robinson)

Above right: View of the south face of the castle from the Mill Garden. (Author)

Nelson Family

> You great benefactors, sprinkle our society with thankfulness.
> Timon in *Timon of Athens* (Act III, Scene 6)

Several local streets in north Warwick are named after members of the Nelson family. The Nelsons were a truly remarkable family who had a profound influence for good on the life of the people of Warwick. It all began with George, born in Nottingham in 1800, whose father and uncle were both said to have 'been ruined by the American War'. Young George had a gift for chemistry, and together with his brother-in-law Thomas Bellamy Dale, he later founded the business George Nelson, Dale & Co. Ltd, which was ultimately to become the town's largest employer and involve every subsequent generation of his family, until its closure in 1972.

George was born into a family that had hit hard times during the decades before his birth. However, it seems that he had inherited a good business mind. After studying chemistry and moving to live in Leamington Spa, he opened two chemist's shops. It was there, in a laboratory in Regents Place, that Leamington Salts were said to have been first manufactured – by evaporation from the celebrated saline.

George later moved to Rock Mills by the River Avon (just outside the Warwick town boundary), and whilst there took out his first patent for the manufacture of gelatine in 1837. He aimed to improve on the centuries-old practice for making jellies: he wanted to develop a product that was colourless and odourless, consistent in texture, and didn't leave an aftertaste. The sale of his gelatine product increased rapidly, and in 1841 the firm moved to Emscote Mill, a steam-powered mill in Wharf Street, where their factory covered over 5 acres.

George died in 1850 and is buried in the churchyard at Old Milverton, overlooking Guy's Cliffe House and the Saxon Mill. Five sons survived him, of whom George Henry took over the management of the company. Becoming a member of the town council, he twice served as mayor. One of his young brothers Edward Montague succeeded him and ran the Warwick Gelatine works after his death; he and his grandson Guy were also to become mayors of Warwick. Edward Montague built up a huge network of companies trading and investing in Australia and New Zealand, freezing and importing meat.

A–Z of Warwick

During the time of George Henry and Edward Montague, the company built sixteen houses for their workers in Wharf Street, which soon became known as the Nelson Village. Then the road itself was renamed Charles Street after their brother Charles, who had died in 1877 at the age of forty-three.

Located in Charles Street, the Nelson Club is today an active and thriving reminder of the benevolent effect of the Nelsons on the local community. This club, built by George Henry and Edward Montague, served as a social club for the employees of their business, and Edward Montague was the president. The club today is a popular venue for hire by local community organisations. In the early days of the club, the employees of Messrs Nelson, Dale & Co. put on a production each year, which played for two nights. In this way, the Nelson family used their gifts for business acumen and philanthropy to improve the lives of many Warwick people for nearly one and a half centuries.

George Henry Nelson 1868–1870 and 1876–1878
The Nelson gelatine works, founded by George Nelson around 1840 became Warwick's largest employer. After George's early death his son, George Henry, managed the company and became a member of the Town Council and twice mayor. A younger brother, E M Nelson, and his grandson Guy, were also to become mayors of Warwick.

Sir Edward Montague Nelson 1918–19
Nelson built up a huge network of companies trading and investing in Australia and New Zealand, particularly freezing and importing meat. He also ran the Warwick gelatine works after the death of his brother George Henry.

Above: Sign giving information about the Nelson brothers, George Henry and Edward Montague, in the Warwick Visitor Information Centre. (Author)

Left: The Nelson Club in Charles Street blue plaque. (Author)

O

Oisin the Irish Giant Deer

> It would do well to set the deer's horns upon his head for a branch of victory.
> Jacques in *As You Like It* (Act IV, Scene 2)

In the Warwick Market Hall Museum we may find Oisin, pronounced 'o-sheen', another of the museum's outstanding fossil exhibits. Oisin, as he has been named by museum staff, is an Irish giant deer.

The skeleton on display in the Market Hall Museum is probably made up of bones from more than one skeleton, collected from peat bogs in Limerick, Ireland, in the middle of the nineteenth century. The reconstructed skeleton was acquired by the Warwickshire Natural History and Archaeological Society in 1866 and is roughly 11,000 years old.

Irish giant deer are known as *Megaloceros giganteus*. They finally became extinct about 8,000 years ago and were the largest deer that ever lived. It is thought that they died out because of climate change and were unable to adapt to the warmer climate following the last ice age.

Heritage Culture Warwickshire have set up a Twitter account called 'Oisin the Deer', which they use as a platform to share heritage and culture events, activities and museum news. Oisin tweets regularly about what's going on in the museum and around the county and welcomes tweets from his followers. In this way, the museum helps young people to engage with this extraordinary creature and to imagine how he must have looked during his time on the Earth.

Oisin the Irish giant deer in the Warwick Market Hall Museum. (Author by permission of Warwickshire Museum)

P

Peacocks

> Here on this grass-plot, in this very place
> To come and sport: her peacocks fly.
>
> Iris in *The Tempest* (Act IV, Scene 1)

In 1870, garden designer Robert Marnock, under the direction of George Guy Greville, 4th Earl, added a hexagonal parterre and a rose garden to the castle grounds, and later, the earl introduced peacocks. Subsequently the parterre became known as the Peacock Garden, which is also reflected in the sculptured topiaries. Local residents, especially in Castle Lane, are kept well aware of the peacocks, not only by the penetrating sound of their call, but also by those few who sometimes cannot resist a brief escape over the wall, across the road and into their front gardens.

A flock of over forty peacocks now roams the castle grounds. These glorious birds are a source of delight for visitors and may be admired as they stroll around the parterre and the centrepiece fountain, and rest on the hedges. Sometimes they may be spotted paying a visit to the battlements or stopping off at the picnic benches. Peacocks are not indigenous to the UK. Originally native to south Asia, they are thought to have been introduced to western Europe by the ancient Greeks and introduced to England by the Romans.

Peacock resting on hedge in the Peacock Garden at Warwick Castle. (Courtesy of Jamie Robinson)

P

Peacock showing his feathers in the Peacock Garden at Warwick Castle. (Courtesy of Jamie Robinson)

Their presence at the castle dates to the 1890s when Daisy, 5th Countess of Warwick, kept a menagerie on the River Island. The peacocks then were accompanied by an emu, elephant, deer, and an ant bear. Sadly, the days of the menagerie ended following a tragic incident involving a deer. Tour guides through the State Rooms will tell you the full story when you reach the Blue Boudoir, Daisy's favourite room. Here, panoramic views can be obtained from two directions, including the best possible view of the River Island.

Park Cottage

> I pray thee, if it stand with honesty,
> Buy thou the cottage.
> Rosalind in *As You Like It* (Act II, Scene 4)

Park Cottage, built in the sixteenth century to house the castle dairy, today stands between Tudor Court and the road to the castle car park.

This beautiful Grade II listed timber-framed property was originally sited close to the twelfth-century St Lawrence's Church. The first floor is an excellent example of a jettied cross-wing: the side walls have large medieval panels of wattle and daub with timber braces to add rigidity to the framing. Today, Park Cottage draws our admiration as a perfect example of the beauty of construction in Tudor times, retaining original timber beams inside. It is now open as a guesthouse for visitors to Warwick, an ideal location from which to spend a few days exploring all that the town has to offer.

Park Cottage, West Street. (Author)

Priory Park

> Why so large cost, having so short a lease,
> Dost thou upon thy fading mansion spend?
>
> 'Sonnet 146'

Priory Park formerly belonged to the twelfth-century Priory of St Sepulchre, and late twentieth-century excavations revealed that the religious house had been built over three earlier limekilns. Now the site is occupied by the County Record Office. For nearly 900 years a succession of buildings has stood on this low sandstone hill to the north of Warwick. During that time the building underwent many changes, from religious house to grand manor. It saw elaborate architectural improvements and was home to several outstanding public figures. Then it suffered a period of decline, which took it to its fate: demolition.

Henry de Newburgh, 1st Earl of Warwick, founded the priory here for the order of the Canons of the Holy Sepulchre, who cared for pilgrims to the Holy Land. After the fall of Jerusalem seventy years later, the house became indistinguishable from an ordinary Augustinian priory. At the Dissolution of the Monasteries, the prior, Robert Radford, and three canons surrendered the house to the crown.

Ten years after the Dissolution, Thomas Hawkins (alias Fisher) came to live in the priory. He was a servant of John Dudley, created Earl of Warwick in 1547, who was executed in the reign of Mary I for trying to put Lady Jane Grey on the throne together with his son Guilford. Fisher pulled down the old buildings of the priory and built a mansion over the next twenty years, which he called 'Hawkyns Nest'. In 1581, his son sold the property to John Puckering, a lawyer, who became the Speaker of the House of Commons, Keeper of the Great Seal, and was eventually knighted. Sir John or his widow remodelled the house between 1581 and 1611, and the west front gained an impressive symmetry with a row of six great ogee headed gables rising above the parapet.

In the reign of Queen Anne, Henry Wise, royal gardener, purchased the property; his son added a huge square wing facing the terrace in around 1745. The Wise family hung onto the property until the mid-1800s, when Henry Christopher, great, great grandson of the royal gardener, sold it all to the Oxford Junction Railway Company.

The now very large mansion passed through various hands and restorations until an American couple, Alexander and Virginia Weddell, bought it at a demolition sale in 1925. With that, the mansion met its sad end, but had a curious afterlife: several thousand tons of the stones and other materials were shipped to the USA for the building of Virginia House, Richmond, Virginia. Alexander and Virginia signed the house to the Virginia Historical Society, who still maintain it today.

Warwickshire County Council acquired the estate in 1940 but were unable to go ahead with any plans for it until the war had ended. In 1953, Priory Park opened to the public and twenty years later, excavations revealed burials, presumably under the floor of the priory church, and the outline of a small room with the base of a central column. Most of the foundations were, however, obliterated by the cellars of the Tudor mansion and its later additions. Very little evidence remains now of the earlier buildings.

Warwickshire County Records Office, on the site of the former manor house in Priory Park. (Author)

View of Priory Park. (Author)

Quaker Meeting House

> I have lived at honest freedom.
> Belarius in *Cymbeline* (Act III, Scene 3)

The Quakers first emerged in England in the second half of the seventeenth century, during the aftermath of the English Civil War, a time when many people longed to reshape religion, politics, and society. Early Quakers started preaching around the North of England, and then further afield around Britain, gathering followers fired up by their radical ideas.

George Fox, one of the founders of the Religious Society of Friends, held a meeting in Warwick with his supporters in 1655. By the following year, a group of 'Friends' had been established. The Society of Friends bought the land at No. 39 High Street fifteen years later where they built their meeting house, probably a converted timber-framed house or barn. This was destroyed in the Great Fire of Warwick of 1694, which started nearby. The Quakers soon made plans to rebuild and finished their new meeting house just a year later.

This building now stands in its own secluded courtyard away from the street with a tranquil garden open to the public. Quakers stopped meeting there in 1912. Four years after the end of the Second World War, however, Friends from Leamington Spa reopened it, and regular meetings have taken place there since 1954.

The key beliefs of Quakerism were formed during radical times. They include the idea that everyone can experience 'inner light' with no need of a priest, or the Bible. No strict rules govern their Church – how each individual chooses to act, so longer as their choice is driven by this 'inner light', is valid. Early Quakers also preached there was no need for churches, rituals, holy days, or sacraments to practice religion. Rather religion should be something one lived and acted out every day. Throughout their history, Quakers have campaigned for the rights of prisoners, refusing to fight in wars, mediating in conflicts, and becoming the first religious organisation in Britain to officially recognise same-sex marriage.

Early Quaker gatherings and the organisational structure, set up in the seventeenth century, remains much the same today; Quakers gather to meet, usually once a week,

to sit in stillness and wait, often in silence. Predictably, in the early days, the political and religious establishment felt threatened by their beliefs, and many early Quakers were imprisoned and oppressed – and some, as we have already seen, were held in the dungeon in the Old Gaolhouse in Northgate Street.

Quaker Meeting House courtyard. (Author)

Quaker Garden. (Author)

Racecourse

> Then should I spur, though mounted on the wind...
> Then can no horse with my desire keep pace.
>
> 'Sonnet 51'

The Racecourse is one of the oldest in the country. The first race was held in 1694 to raise money for the town after the great fire of that year. Thirteen years later, Fulke Greville, 5th Baron Brooke, donated £15 'towards making a horse race' to be run at Warwick on 16 September 1707, which was the first race run on St Mary's Land, now known as the Racecourse. The first stand did not open until over a hundred years later, in 1808. Warwick, with Coventry, opened the flat racing season for several years in the nineteenth century. Many notable jockeys have raced at Warwick, including Lester Piggott and John Francombe.

The income received from renting out the common lands for racing contributed to the demise of 'drives' in the nineteenth century (where cattle were rounded up, and commoners paid for their release). After the Second World War, it was uneconomic

Warwick Racecourse. (Author)

to continue the racing unless the course could be legally closed on race days. An Act of 1948 allowed for the sale of the land and thus, the Commonable Lands became municipal property.

In the book *Chandlers Leap and other stories from Warwick Racecourse*, we learn that the three centuries since that first race funded by Lord Brooke in 1707 have seen many great horses gallop over Warwick Racecourse

> ...partnered by the finest of jockeys. The racecourse has also been the venue for a plethora of non-racing activities, ranging from bare-knuckle boxing contests to military parades.

Alan Bailey of the Warwick Rotary Club describes how

> the local Warwick Racecourse Jockey Club Manager and his team embarked on a major exercise of developing ... a masterplan for St Mary's Lands which eventually delivered improved access for the people of Warwick to a large open space ... The Racecourse now responds in a positive way to make community life that much better in Warwick.

Sheila Johnson, a former Racecourse steward at both Cheltenham and Warwick, says:

> As a member of the Jockey Club team ... wearing our uniform of white shirts, gold ties, and black waistcoats ... I would work in the corporate boxes ... on the cash till taking the guests' payments for food and drinks ... although you were much less likely to see any action on the racecourse as the boxes were mainly internal with no view of the racecourse.

Now many community activities take place on the racecourse including firework displays and such events such as 'Open Air Film and Chill' on a giant screen such as this one of *Mamma Mia* in May 2022.

'Open Air Film and Chill': *Mamma Mia* at the Warwick Racecourse, summer 2022. (Author)

A–Z of Warwick

Randolph Turpin

> He had some feeling of the sport.
> Lucio in *Measure for Measure* (Act III, Scene 2)

A statue of Randolph Turpin stands in Warwick Market Place, created by sculptor Carl Payne, commemorating Britain's first black world champion professional boxer, who grew up in Warwick. He won the title of Middleweight Champion of the World in 1957 and died at the age of thirty-eight. His statue was unveiled in Warwick by Sir Henry Cooper and Randolph's brother Jack on 10 July 2001.

Randolph Adolphus 'Licker' Turpin won numerous Championship titles during his short life, including British Middleweight, World Middleweight, British and Empire Light Heavyweight, British Empire Middleweight and European Middleweight. His brothers Lionel Cecil 'Dick' and John Matthew 'Jack' both won boxing champion titles too, and the trio were known as the Boxing Turpin Brothers. However, Randolph was the only one to win the supreme accolade, and thus he is commemorated by this Warwick statue, which was donated by the Randolph Turpin Memorial Fund chairman Adrian Bush.

Randolph Turpin statue, front, in the Market Square. (Author)

R

Randolph Turpin statue, back, in the Market Square. (Author)

Born in Guyana, Randolph's father was invalided to Warwick from the battlefields of the First World War. He married a local girl, and Randolph was born in nearby Leamington Spa in 1928. The Turpin family moved back to Warwick when Randolph was small, where he attended Westgate School and trained in a Warwick gymnasium.

After a glittering amateur career, Randolph served with the Royal Navy. His finest hour as a professional boxer came when he dramatically outfought the legendary American middleweight Sugar Ray Robinson to become Britain's first black World Champion. 'In palace, pub and parlour, the whole of Britain held its breath,' said writer Terry Fox, in a book co-written with Randolph's brother Jackie. Randolph's boxing gloves are now held in the collection of Leamington Spa Art Gallery & Museum.

Randolph, however, had a tragic flaw in his character: during the final years of his life, unable to handle his finances, he felt overwhelmed by bankruptcy and tax demands. His death in 1966 from gunshot wounds, just short of his thirty-eighth birthday, was ruled to be suicide yet disputed by his family to be murder. At his funeral it was said that his sad end was more the fault of our society than of Randolph himself, whose vulnerability robbed him of the ability to handle fame and fortune. He is buried in Leamington Cemetery. In 2001, Randolph Turpin was posthumously inducted into the International Boxing Hall of Fame in recognition of his outstanding achievements in the ring.

Painting of Randolph Turpin in the Warwick Visitor Information Centre. (Author)

Rous, John

> The foolish chroniclers of that age.
> Rosalind in *As You Like It* (Act IV, Scene 1)

John Rous, a medieval historian to whom we owe a great deal, was the chronicler who provided us with compelling evidence that Richard III's nefarious reputation is largely due to Tudor propaganda. Rous was born in Warwick in 1420 to a family of 'gentry'. Educated at Oxford, he lived near Warwick most of his life, during which he claimed his place in history as a historian and as the author of a key historical document known as the Rous Roll, which is about the Beauchamp family. He also served as chantry priest in the Chapel of St Mary Magdalene at Guy's Cliffe during the reign of Richard III.

In 1480, he began work on his *History of the Kings of England*, a document intended to give Edward IV information about kings and high-ranking clergy who might be commemorated with statues in St George's Chapel, Windsor. Rous took six years to finish this, and so its composition stretched over the turbulent period of Edward IV's death in 1483, the brief minority rule of Edward V, and the reign and death of Richard III (killed at the Battle of Bosworth Field in 1485). The finished work was dedicated to Henry VII. That dedication says everything about the likely truth of all that is written about Richard III within its pages; Tudor propaganda was so powerful it has teased and tested historians ever since.

R

John Rous, chantry priest at Guy's Cliffe during the reign of Richard III. (Public domain)

The Rous Roll was created for the Beauchamp family during the brief reign of Richard III. It was possibly commissioned by Anne Neville, Richard's wife. Written in a period of English history that saw power in the hands of the House of York, the author is clearly reflecting the views of his time, and this gives a fascinating glimpse of a contemporary view of the perceived standing of Richard.

Rous's account is primarily anti-Ricardian propaganda looking to win favour with his successor. Rous is the first historian to focus attention onto Richard's small size and his physical impairment (implicitly capitalising on medieval ideas that such things were a judgement from God and sign of evil). Rous also invents a legend of unnatural and monstrous birth. He writes:

> Richard was born at Fotheringhay in Northamptonshire, retained within his mother's womb for two years and emerging with teeth and hair to his shoulders … At his nativity Scorpio was in the ascendant, which is the sign of the house of Mars … like a scorpion he combined a smooth front with a stinging tail … He was small of stature, with a short face and unequal shoulders, the right higher and the left lower … For all that, let me say the truth to his credit: that he bore himself like a noble soldier and despite his little body and feeble strength, honourably defended himself to his last breath.

However, when Richard III was on the throne Rous referred to him as a 'mighty prince' of 'bounteous grace'.

Saltisford Canal Trust

> How many shallow bauble boats dare... making their way
> With those of noble bulk!
>
> Nestor in *Troilus and Cressida* (Act I, Scene 3)

The Saltisford Canal Centre may be entered via the Birmingham Road into Warwick. The dawning of the canal age briefly bought hope to Warwick's traders in the last years of the eighteenth century, and waterways built by two separate undertakings met at Saltisford. The Warwick and Birmingham and the Warwick and Napton canals both opened in early 1800 but were never particularly successful. After decades of struggle, both eventually became part of the new Grand Union system in 1929.

A canal trust was set up in 1988 to restore the Saltisford Canal Arm, which dates to 1799, and was originally the terminus of the Warwick and Birmingham Canal. The canals are still in use, for leisure now rather than for trade, and the towpath walks give a very different perspective of Warwick. The only major engineering work in the

Saltisford Canal Centre. (Author)

The former gasworks at Saltisford. (Author)

town connected with the canals is the Avon Aqueduct, taking the former Warwick and Napton line over the river.

Warwick can still boast one of the most important industrial buildings in the country, however, and one that was served by the canal basin in Saltisford. The development of gas lighting in the early nineteenth century revolutionised the way towns looked at night. The former gasworks building in Saltisford, now Grade II listed, dates from 1822, and was one of the first gasworks in the world. The circular gas holders (or gasometers) were hidden inside the two octagonal towers (with false windows). More recently the main building has been used as offices. After ten years of disuse, this very attractive building is now converted into residential apartments.

Smith Street

> See our tradesmen within their shops and going about their functions friendly.
> Sicinius in *Coriolanus* (Act IV, Scene 6)

Smith Street, the oldest shopping street in the town, contains four medieval timber-framed houses along with a mix of buildings from every period between the fifteenth and eighteenth centuries. As you head through the East Gate you enter this, formerly the most thickly developed area on the east side of town; it escaped the ravages of the great fire, which is why so many period properties have survived.

At the top of the slope on the north side of the street is a group of buildings consisting of a timber-framed jettied range known as 'The Cottage', and Landor House, formerly occupied by King's Girls' High School. The Cottage was probably built in 1500 and divided to provide homes for two families. Landor House, where the essayist Walter Savage Landor was born in 1775, incorporates at its rear a medieval timber-framed wing in Chapel Street. It joins the Cottage on its west side and probably replaces a former building there.

The Roebuck Inn, at the eastern end of the street on the north side, is Warwick's oldest inn. Restored and altered probably in the late sixteenth century, it has been a hostelry since the year 1470. A similar date may be assigned to the twin-gabled house immediately west of the inn. The Roebuck Inn sign today still looks much as it did in the late 1960s.

View up Smith Street to the East Gate. (Author)

Nos 7–9 Smith Street showing the mix of buildings from fifteenth to eighteenth centuries. (Author)

Landor House, The Cottage, and East Gate. (Author)

Twin-gabled house to the west of the Roebuck Inn. (Author)

The Roebuck Inn. (Courtesy of Jamie Robinson)

The Roebuck pub sign. (Author)

Tudor House Inn

> O blessed bond of board and bed.
>
> Hyman in *As You Like It* (Act V, Scene 4)

The fine fifteenth-century Tudor House Hotel is the outstanding house in West Street, a large timber-framed building of two storeys and gabled attics. The form of the medieval suburb of West Street has persisted until the present day with remarkably few changes. The line of small dwellings at each side of the road to Stratford terminated at the site of St Lawrence's chapel until the twentieth century, and many of the houses remain to make this the most picturesque approach to the town along tree-lined pavements. The steep incline towards the West Gate gives some idea of Warwick's defensive strength. The suburb in 1830 was described as 'wide and airy' and consisted of 'low houses inhabited by the working classes of the community'. The hearth tax returns of two centuries earlier confirm the impression of small houses; the average for the district was under two hearths in each house, and fifty-five were not liable to taxation at all.

The Tudor House Inn in West Street. (Author)

The Tudor House Inn was originally a two-bay building with central stack and lobby entrance, but later incorporated a lower building at the east end as a further bay to form the present 'L' shaped plan. Having survived the great fire of Warwick, it is another of the oldest buildings in the town and is also the nearest pub to the West Street entrance into Warwick Castle.

In October 2019, new owners opened a Spanish restaurant called Flamenco, but sadly their project was short-lived, ending with the Covid pandemic and the first lockdown. However, that October, the hopeful new manager, and staff, unaware of what lay ahead, reported to a journalist from the *Coventry Telegraph* that they had begun to experience ghostly incidents, including flying glasses, shadowy figures, and a self-rocking rocking chair. It may be left to others to speculate whether the spirits of this Tudor property did not take kindly to the idea of the building being used as a Spanish restaurant. The 1500s saw years of religious and political differences between Spain and England leading to open conflict.

Nevertheless, the new owners claimed they 'respected the history of the place'. Alarming incidents in room ten of the hotel, and numerous apparitions had been reported, over several years, including that of a maid in black and white costume, a child's face in a window halfway up the stairs, and a man sitting smoking at the bar wearing a distinctive hat adorned with a long feather. Such stories are familiar throughout the historic buildings of Warwick, and we are unlikely to find management in any of these properties who fail to recognise the potential for these hauntings to attract new clientele!

Trebuchet

...as fearful as a siege.
Imogen in *Cymbeline* (Act III, Scene 4)

In medieval warfare, the trebuchet was a powerful weapon, a siege engine whose purpose was to fire projectiles at castles to breach the walls. The current trebuchet at Warwick Castle stands on the River Island within the castle grounds and is a large replica trebuchet built in 2023 to replace the previous one, which was worn out and no longer safe to fire. In fact, on one occasion, the ammunition hit the boathouse, and burned it to the ground. Fortunately, the boathouse has now been rebuilt and is in perfect condition!

Like its earlier version, the new trebuchet has been given the name Ursa (Latin for bear), after Warwickshire's famous bear and ragged staff emblem. 18 metres high and 22 tons in weight, Ursa was built by Carpenter Oak using over 300 pieces of oak, and is a replica created to exact historical standards, based on original designs from the thirteenth and fourteenth centuries. The new Ursa was launched to the public in a brand-new live show at the castle on Saturday 1 April 2023.

Ursa, the new trebuchet at the castle being fired for the first time on 1 April 2023. (Courtesy of Jamie Robinson)

Ursa is a counterweight trebuchet, which has been described as the 'most powerful weapon of the Middle Ages'. The earliest known description and illustration of a counterweight trebuchet comes from a commentary on the conquests of Saladin by Mardi ibn Ali al-Tarsusi in 1187. The counterweight and traction trebuchets were phased out around the mid-fifteenth century in favour of gunpowder weapons.

When trebuchets were in use, large rocks or stones were the most common ammunition but there are records of other more unusual materials being used including incendiary projectiles to cause fire, animal carcasses and sewage to spread disease, and the heads or limbs of prisoners to strike fear into the enemy. During peak siege warfare a skilled crew would attempt to launch a projectile every six minutes.

Ursa operates as these weapons would have done in siege warfare using winders in the wheels coordinated by a trebuchet master, launching an 18-kilogram projectile approximately 250 metres. The ammunition is fired to the south across the River Island, well away from the castle walls, and from the watching audience!

U

Unitarians

> Bear free and patient thoughts.
> Edgar in *King Lear* (Act IV, Scene 6)

Unitarianism as an organised church grew out of the Protestant Reformation of the sixteenth century. It started in Poland and Transylvania in the 1560s and was recognised as a religion in Transylvania within ten years. In England, Unitarian ideas were being discussed by the mid-1600s in the writings of John Biddle (1615–62), and the first Unitarian congregation came into being in 1774 at Essex Chapel in London, founded by a former Church of England minister, Theophilus Lindsey. The distinguished scientist and minister Joseph Priestley also played a key role in the formation of the movement.

Around the year 1758, the Nonconformist church members of Warwick split into Congregationalists and Unitarians. The former moved into a chapel in Brook Street, which is now known as Brook Hall and used as office premises. A plaque in the castle conservatory commemorates those early Nonconformists.

Brook Hall, formerly Brook Street Chapel used by the Nonconformists. (Author)

The Warwick Unitarians meet in their chapel in the High Street, which is also hired out to local organisations for numerous activities including choir rehearsals, concerts and weddings. Built in 1781 to serve Nonconformists, the chapel was resited here when the castle grounds were extended. Years before that date, the Nonconformists of Warwick met in a chapel which stood on the very site now occupied by the castle conservatory. The earl acquired the chapel and the land on which it stood in 1780 and absorbed them into the castle grounds. In exchange, the Nonconformist church received its present site in the high street, and behind it today a beautiful garden filled with roses and hollyhocks may be found.

Today, Unitarian Universalism encompasses liberal Christians, Jews, Buddhists, humanists and followers of earth-centred spirituality (neo-pagans) within its ranks. Warwick Unitarians have this message:

> Our religious beliefs are not prescribed, as we believe that religion is wider than any one sect and deeper than any one set of opinions. Within our community there are those who would consider themselves to be Christians, whereas others share only some of the Christian beliefs. There are also those who have come to us from other backgrounds – atheist, humanist, and agnostic. Labels are not so important to Unitarians – our shared bond is one of friendship and the aim of seeking deeper meaning in our lives. We find a basis for unity in our shared search for truth and a mutual respect for sincerely held beliefs. We encourage all our members, visitors, and friends to find a level of belief with which they feel comfortable.

Unitarian Chapel in the High Street. (Author)

V

Vehicles: the Austin Healey Motor Company

> Three of the carriages, in faith, are very dear to fancy, very responsible to the hilts, most delicate carriages, and of very liberal conceit.
>
> Osric in *Hamlet* (Act V, Scene 2)

A blue plaque on a block of retirement flats in Coten End commemorates the fact that this site was occupied by the showrooms of the Donald Healey Motor Company from July 1963 to December 1974. Now known as Healey Court, it is one of the Warwick locations associated with Donald Healey, renowned for designing and building an iconic car, much loved by enthusiasts worldwide and now the subject of restoration.

Towards the end of the Second World War, Donald Healey and two of his colleagues at Humber, where they all worked, began to draft ideas for a brand-new 100-mph sports car. Donald Healey's first factory, where Healey sports cars were developed and initially produced, was at the Cape Works, in Lock Lane, Millers Road, Warwick. The cars were being developed and built between 1946 and 1963. During those seven years, Donald Healey produced a range of cars: the Healey was quick to capture the public imagination as early as 1946. The Market Hall Museum presented the exhibition Healey: Cars for Speed and Glamour from 19 May 2021 to 21 March 2022 and a historical video about the Healey Motor Company forms part of the permanent display.

Today, the works in Lock Lane are occupied by JME Healeys, whose business is to restore Austin-Healeys and to prepare them for competition.

Blue plaque commemorating the Healey Car Showrooms at Healey Court, Coten End. (Author)

JME Healeys, the Restoration Works at The Cape Works, Lock Lane. (Author)

W

Warwick Arms Hotel

> When I am in my coach, which stays for us
> At the park gate...
> Portia in *The Merchant of Venice* (Act III, Scene 4)

The Warwick Arms was originally a coaching inn, the property of the Earls of Warwick and is the oldest established hotel in Shakespeare's County with a history dating back to 1591. The current eighteenth-century building replaced the one burned down in

The Warwick Arms Hotel, High Street. (Author)

the great fire. The oldest part of the building is the wing running back on the right of the entrance hall. A section of the original walls has been exposed and restored. It was built in neoclassical style and faced with the local Triassic sandstone.

The earl leased the property in exchange for the Cross Keys Inn, which was demolished when he enclosed part of the town into the castle grounds in the 1780s. In 1790 the building became known as the White Swan, and Swan Street opposite was named after the inn. Originally, a coaching entrance led from the High Street to the inn yard behind, for stagecoaches depended on a chain of coaching inns, where horses and drivers could be changed as necessary.

The current stone frontage to the hotel was built by 1815, when a local guidebook referred to it as 'a pleasing style of simple elegance', thus strengthening its reputation of being the superior inn of the town. One writer described it as 'more pretentious' than its rivals. In October 1819, the earl held his Court Baron there, and around the same time the Warwickshire Yeomanry used it as their officers' mess, when there was

The bunch of grapes on the front of the Warwick Arms Hotel. (Author)

stabling for seventy-five horses behind the inn. The stable yard became the scene of a tragedy: John Spicer, a trumpeter with the Warwickshire Yeomanry, fell off his horse, and died the following year. By 1843, the Warwick Arms was calling itself a 'hotel', a French word used by the more upmarket inns.

In 1928–29, the hotel expanded, taking over Nos 19 and 21 High Street. But just ten years later, in June 1939, a reversing lorry destroyed the portico following which the license was suspended. The building was used as a government department until the end of the Second World War, when it once again reopened as a hotel. Despite all the changes over the years, the bunch of grapes which hangs above the main High Street entrance is reputed to be the oldest inn sign in the country and is thought to date from one of the early Earls of Warwick.

Warwick a Singing Town

And I in deep delight… as himself to singing he betakes.
The Passionate Pilgrim

In former times, in England, communal singing was more widespread than today, and a natural part of daily life. The love of singing for its own sake is something two people in Warwick felt passionate about restoring to our community. When Jeremy Dibb and Richard Nicholson got together in 2017, they came up with a plan.

They had both spent their professional lives in music: for the last three decades of his career, Jeremy had worked for the Warwickshire County Music Service, and Richard was headmaster at Kings High School (and is now, at the time of writing, Principal of Warwick Independent Schools foundation). From the time they first started chatting about their experience of the local musical scene they discovered they were of one mind about the woeful lack of music and particularly singing in schools, following the loss of local and central government funding in 2015.

After Jeremy retired, he and Richard came up with an imaginative idea to transform the profile of music in three key areas of life here in Warwick: education, health, and community. They worked out a full business plan to present to the trustees of King Henry VIII Endowed Trust, which met with success, and the initiative Warwick a Singing Town was born.

The trust is one of the oldest charities in the country, having emerged from negotiations with Henry VIII's commissioners in the mid-sixteenth century. The Chantries Act had just been passed, which allowed Henry to confiscate the property of the church throughout his kingdom. However, before this could happen in Warwick, Thomas Oken, then master of the United Guilds, stepped in with an alternative plan to put to the Crown. In exchange for certain church lands and payments, Henry VIII agreed to sign a charter by which he gave back some tithes, profits, properties, and land holdings to the town of Warwick in the form of the Charity of King Henry VIII,

and in 1546 the town was incorporated as the Bailiff and Burgesses of the Borough of Warwick.

This charity lives on today, with half of its distribution benefiting the five Anglican churches of the town. 30 per cent goes to the Warwick Independent Schools foundation (to fund means tested bursaries for Warwick children) and the remaining share is available for discretionary grants that benefit the local community.

The initiative means that for at least three years, teachers in all schools in the CV34 postcode will have the input of three dynamic choral entrepreneurs: Ben Hamilton, Mariana Rosas, and Cerys Purser. Ben, Mariana, and Cerys go into schools, and they are, at the time of writing, singing with 1,600 children there every week.

Alongside the King Henry VIII Charity funding, Warwick a Singing Town also has support and financial help from the Warwick Independent Schools foundation. For the community strand of their vision, they encourage and promote existing singing groups in Warwick and where they see a gap, they seek to fill it. The project provides a valuable boost to local choirs, with, for example, the Warwick Choral Festival, June to July 2022, which showcases several singing ensembles and choirs in six locations around the town. In 2023 they will revive the Warwick Pageant for the first time since

Children from West Gate Primary School singing with Choral Entrepreneur Mariana Rosas. (Courtesy of *Warwick a Singing Town*)

Members of Songlines Community Choir, conducted by Bruce Knight, about to begin their rehearsal in the garden of the Unitarian Chapel, Warwick. (Author)

1906 and in the following year a grand multimedia festival will celebrate Warwick a Singing Town.

To fulfil the health and wellbeing strand of the project, local GPs have also come on board with their 'social prescribing' by which they support patients to access a variety of groups in the local community to increase their wellbeing. Armonico Consort, a locally based professional choir, also partners with Warwick a Singing Town, and they run a Memory Choir for people with Alzheimer's together with their carers.

As of 2022, Warwick is the only Singing Town. But if it works well, and people in other areas of the UK like what they see here, then they too might be inspired to do something similar in their own locality, bringing high hopes that Warwick may be the first but not the last Singing Town.

West Gate and the Chapel of St James

> The poor mechanic porters crowding in
> Their heavy burdens at his narrow gate.
> Archbishop of Canterbury in *Henry V* (Act I, Scene 2)

A–Z of Warwick

The town walls were constructed after Aethelflaed first developed her fortified burgh in 914 as a base from which she could repel the Danes. The walls fell out of use after William the Conqueror's castle became the real strength of Warwick, and subsequently the walls were gradually quarried for building stone. The north gate has vanished and is remembered only by the name of the street and of Northgate House. The west gate and east gate survive because both have chapels built over them, and on the south, the town is protected by the castle, and the south gate is the town gate through into the castle grounds. Warwick is probably unique in still having two gate chapels.

The west gate of Warwick with the Chapel of St James was built in 1126 by Roger de Newburgh, 2nd Norman Earl. Part of the original town walls with fourteenth-century vaulting may still be seen here, adjacent to the much later almshouses. The ribbed-vault gate-passage is cut into the living sandstone.

South Gate, the town gate into the castle. (Author)

West Gate and the Chapel of St James. (Author)

Almshouses and remaining section of the medieval town wall at the West Gate. (Author)

The chapel was granted by Thomas Beauchamp, 12th Earl, to the new Guild of St George formed in 1383, and later became known as the chapel of the United Guilds of Warwick. In medieval times the town guilds became powerful. As trades and skills arose, they formed companies that controlled the quality of what was being produced, with a corn guild, a leather guild and so on. Tradespeople would bring into town through either of the four gates the produce they needed to use to carry out their trade. The United Guilds controlled the gates and determined who came in by taxing incoming produce.

In the days of their excessive power, a countess of Warwick wrote a letter begging the burgesses to forgo the money on the gate because the townspeople were suffering. It is not known what response she received.

Later in the fifteenth century the Guild Chapel of St James was rebuilt, and the west tower added in 1450, following which the gate passage had to be extended under the chapel. The chapel became ruinous by the mid-sixteenth century, when it formed part of Lord Leycester's Hospital, and the east window was blocked.

We have seen in the chapters on the Court House and the Guildhall how Burgess Hall became Lord Leycester's Hospital, and has remained so ever since, a community for the eight members of the Brethren and their master. Today's residents still regularly use the chapel, which was radically restored between 1863 and 1865 by Sir George Gilbert Scott. He added the balcony on the south side of the chapel to give better access to the main entrance, and from which visitors may enjoy an excellent view in both directions over the town of Warwick.

View down West Street from the chapel walkway at West Gate. (Author)

X

X-rays at Warwick University

> My son and my servant spend all at the university.
> Vincentio in *The Taming of the Shrew* (Act V, Scene 1)

The vibrant and constantly developing university campus located on the border of Coventry and Warwickshire has taken the name Warwick and built an international reputation as one of the world's most highly ranked universities. Though the campus is not in Warwick, it carries the name, which for many concerned with all areas of academic, intellectual, and industrial endeavour has become a name to conjure with, and thus, the university has an honourable mention here.

Physics is an area of science that often catches the popular imagination, and none more so than astrophysics. Warwick University is Europe's leading user of the Hubble Space Telescope, which has captured so many awesome images of our galaxy. On the third floor of the university's new Materials and Analytical Sciences building may be found the X-ray Diffraction Suite, which offers state of the art X-ray scattering services, primarily for materials research and industrial work.

X-rays are a vital part of 'physics at the extreme': in the Astronomy and Astrophysics Group, multi-wavelength observations from radio waves up to X-rays can tell the researchers about the formation and evolution of powerful jets in a wide range of stellar systems and the explosive deaths of stars.

More recently, the scientists of the X-ray Diffraction Suite have been involved in the X-ray analysis of artefacts from Henry VIII's warship the *Mary Rose*, in collaboration with the University of Ghent. This analysis has shed new light on the construction and conservation of those artefacts, now on display with the recovered ship at Portsmouth Historic Dockyard.

This sculpture outside the Materials and Analytical Sciences building, the Needle of Knowledge Obelisk by artist Stefan Knapp, encompasses the past, the present and the future.

The Needle of Knowledge Obelisk by artist Stefan Knapp in front of the Materials and Analytical Sciences Building, Warwick University. (Author)

Y

Yeomanry

> Bravely in their battles set,
> And will with all expedience charge on us.
> Earl of Salisbury in *Henry V* (Act IV, Scene 3)

Warwick has three military museums in total: the Royal Regiment of Fusiliers Museum at St John's House; the Museum of the Queen's Royal Hussars in Trinity Mews, Priory Road; and the Warwickshire Yeomanry Museum in the Court House. For this book, I chose to visit the last museum and find out about the Warwickshire Yeomanry.

On 25 June 1794, the Earl of Aylesford raised a Corps of Yeomanry Cavalry of four troops of fifty-four men, including officers. The funds were provided by public subscription within Warwickshire as: 'a means of helping the internal defence of the UK and for the protection of the peace and security of the country'. These were the Gentlemen and Yeomanry of Warwickshire, who, two years, later became known as the Warwickshire Regiment of Yeomanry Cavalry. They expanded to a fifth troop in 1813, a sixth in 1831, and in 1854, with the Crimean War causing an upsurge in martial sentiment, two more troops were formed. The Yeomanry was not intended to serve overseas, but due to the string of defeats during Black Week in December 1899, the British government realised they would need more troops than just the regular army. A royal warrant was issued on 24 December 1899 to allow volunteer forces to serve in the Second Boer War.

The Warwickshire Yeomanry served as cavalry and machine gunners in the First World War and as a cavalry and an armoured regiment in the Second World War. In 1957, a combined regiment emerged, which became known as the Queen's Own Warwickshire and Worcestershire Yeomanry.

The Warwickshire Yeomanry is famous for 'The Affair at Huj.' Philip Wilson, Archivist for the Warwickshire Yeomanry Trust, describes the Charge of the Warwickshire Yeomanry and Queen's Own Worcestershire Hussars at Huj on 8 November 1917 when both regiments were fighting the Turks in Palestine. He says:

On 8 November, the 60th London Division was pinned down by heavy gunfire from a ridge near Huj in Palestine. This famous Charge is generally considered to be the last classic unsupported Cavalry Charge against guns in British military history and is immortalised by the Lady Butler painting of 'The Affair at Huj' which is in the Warwickshire Yeomanry Museum together with one of the captured guns. Major Oscar Teichman, the Medical Officer for the Worcestershire Yeomanry writing in The Cavalry Journal in 1936 said: 'The Charge at Huj had it occurred in a minor war would have gone down to history like the Charge of the Light Brigade at Balaclava.' In the Great War when gallant deeds were being enacted on all fronts almost daily it was merely an episode, but as the official historian remarks, 'for sheer bravery the episode remains unmatched.'

The Warwickshire Yeomanry Regimental Museum is located in the Tudor kitchen in the basement of the Court House. The museum covers the history of the regiment 1784–1954, and is a treasure trove of weapons, musical instruments, regimental silver, uniforms, medals, and many other items of memorabilia including epaulettes, a shell case, trench periscope and an Arab headdress, which all open up the stories of those who used them.

The Earl of Warwick's emblem, the bear and ragged staff, crafted out of silver in memory of the 5th Earl of Warwick, Hon. Colonel of the Warwickshire Yeomanry 1912–24. (Author)

One of the most captivating stories tells of a brave initiative by Major R. A. Richardson of Longbridge Manor, Warwick, and his Yeoman, through two days of struggle on board the transport *Wayfarer*.

On 10 April 1915, the regiment embarked on the *Wayfarer* to service overseas as part of the Second Mounted Division. They were enroute to Alexandria, but just off the Scilly Isles, the ship was torpedoed, and the crew and the yeomen had to take to the boats, from which they could hear the horses screaming in the sinking ship. The Yeomanry troopers were picked up by a small steamer, the SS *Framfield*. After a few hours, Major Richardson decided to take a party of Yeomen back aboard the *Wayfarer* to help save the horses, as the ship appeared to have stopped sinking. With six of the nine holds flooded the men got a line to the Framfield, which towed them for two days to Queenstown in Ireland. The Yeomen worked continuously throughout the two days in great danger to calm, protect and care for the frightened horses, many of whom were standing in water, and they managed to save 760 of them. Sadly, four Yeomen lost their lives during the incident.

Life-size figure of a Warwickshire Yeomanry trooper on horseback. (Author)

The museum curators have gathered many other photographs, documents, objects, and information which brings history alive, so visitors can see and, in many cases, touch it, and understand more about what it was like to be there in 1914. It would also interest family history researchers inspired by TV programmes like *Who Do You Think You Are?*

Lieutenant Colonel H. A. Gray-Cheape commanded the Warwickshire Yeomanry throughout the entire First World War and then drowned in the Mediterranean alongside 100 others who perished after a German torpedo attack on HMT *Leasowe Castle* in May 1918. His haversack was found drifting at sea, and then recovered from the water and dried out; and his diary was saved. The museum holds that diary, whose water-damaged pages I looked at, together with his photograph and other details of his life.

Completely supported by volunteers, the museum aims to safeguard the heritage and collective memory of those who served with the Warwickshire Yeomanry so that both present and future generations may learn the importance of the past through its history. David Hardy, Chair of Trustees, one of the original trustees, was in the museum when I visited, and alongside him, others also devote themselves to the work of this charitable trust, including Philip Wilson, Trustee, secretary and archivist.

A plaque to the memory of the Warwickshire Yeomanry was unveiled by the town mayor of Warwick on 8 November 2017, the centenary of the Charge at Huj, and the seventy-fifth anniversary of the Battle of El Alamein 'in which the Regiment served with great distinction'. This plaque is mounted on the wall of the Court House close to the museum entrance in Castle Street.

Z

Zenith

> I find my zenith doth depend upon
> A most auspicious star.
>
> Prospero in *The Tempest* (Act I, Scene 2)

The zenith of Warwick the Kingmaker's career came in the 1460s, when Richard Neville, 16th Earl, was the most powerful and influential man in the kingdom. After all, he reasoned, he had helped his cousin Edward gain the throne, so, it was only right that he, Richard Neville, would be his right-hand man.

Richard's wealth was immense by this time, and so was his land ownership. Initially his support had gone to another of his cousins, Henry VI, who had inherited the throne at the age of nine months and been given into the Neville family's care as a baby. Then the adult Henry decided too much wealth was concentrated in the hands of the Earl of Warwick, so, he started taking land and money away from him. In 1461, Richard marched down to London with his eighteen-year-old cousin Edward of York. He had Henry VI locked up in the Tower, crowned Edward and became his adviser. For the next nine years Richard rejoiced in his supreme position as the power behind (and probably controlling) the throne.

Edward also started taking land and money from him; then he married Elizabeth Woodville, a commoner with an ambitious family, and that incensed Richard. He captured Edward, brought him to Warwick and held him in the castle, following which he travelled to London, freed Henry VI from the Tower, and reinstated him on the throne, thus earning the title by which history later came to know him: 'Kingmaker'.

Edward ultimately had his revenge when he defeated his treacherous cousin Richard at the chaotic Battle of Barnet on a misty battlefield on Easter Sunday morning 14 April 1471. Edward then found himself without opposition (his three main antagonists being dead, namely Henry VI and his son, and Richard Neville). Accordingly, he regained the throne, and held onto it for the next twelve years.

In this way, Richard Neville paid the ultimate price for his worldly ambition. He was succeeded as earl by Edward IV's brother, George, Duke of Clarence, who only held

A–Z of Warwick

Richard Neville, 16th Earl of Warwick, known as the Kingmaker. His wax model in the Tussauds Kingmaker exhibition at the castle depicts him preparing for the Battle of Barnet. (Author)

the title himself for six years, during which there was much squabbling with another of his brothers, Richard, Duke of Gloucester (later to become Richard III), over the Warwick inheritance. For, as Shakespeare says through the mouth of Jacques, in *As You Like It*, perhaps it is best after all to be one:

> Who doth ambition shun
> And loves to live in the sun,
> Seeking the food he eats,
> And pleas'd with what he gets
> Come hither, come hither, come hither.
> Here shall he see
> No enemy
> But winter and rough weather.

Bibliography

Synchrotron X-ray diffraction investigation of the surface condition of artefacts from King Henry VIII's warship *the Mary Rose*, published in the *Journal of Synchrotron Radiation*

Quarter Session Minutes reference QS 39; Warwick County Lunatic Asylum records reference CR 1664

'At home in Warwickshire' (*Warwickshire Life Magazine,* July 2011)

Alison Hanham, *Richard III and his Early Historians,* 1483–1535 (Oxford: Clarendon Press, 1975), containing a full-length translation of an extract from Cotton MS Vespasian A XII on Richard III's reign

Websites:
www.bbc.co.uk
www.bl.uk
www.bokeflo.wordpress.com
www.britishlistedbuildings.co.uk
www.canalrivertrust.org.uk
www.carsceneinternational.com
www.coventrytelegraph.net
www.guyscliffewalledgarden.org.uk
www.highspeedhistory.com
www.lordleycester.com
www.nelsonclubwarwick.com
www.ourwarwickshire.org.uk
www.quaker.org.uk
www.racecourseassociation.co.uk
www.thejockeyclub.co.uk
www.warwickdc.gov.uk
www.warwickunitarians.org.uk

Acknowledgements

Every attempt has been made to seek permission for copyright material used in this book. However, if we have inadvertently used copyright material without permission or acknowledgement, we apologise and will make the necessary correction at the first opportunity. The author and publisher would like to thank the following people and organisations for the use of stories and photographs:

Warwickshire Museum for permission to use photographs of the ichthyosaur and the Irish giant deer and to use text for which Warwickshire County Council owns copyright.

Warwick Castle for photographs inside and outside the castle.

Warwickshire Yeomanry Museum for permission to use photographs of exhibits and to use stories from the exhibition.